Vermeer

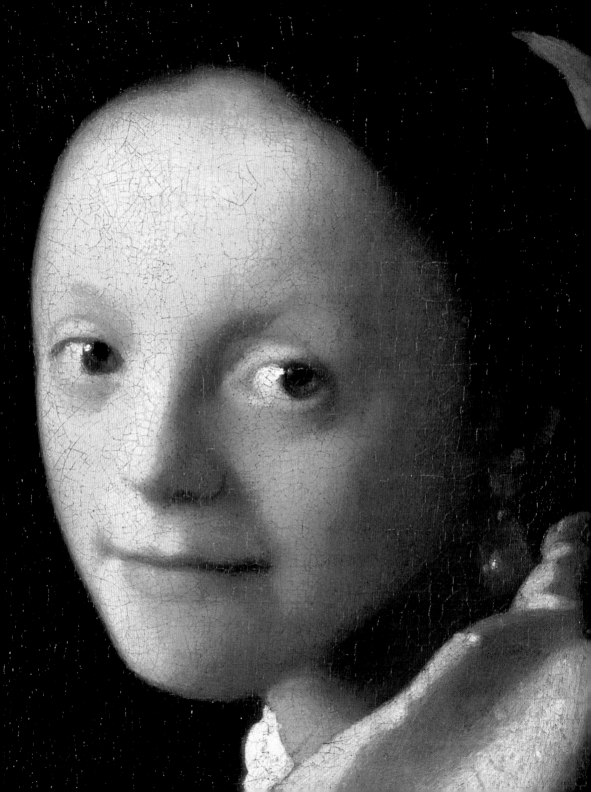

Masters of Art

Vermeer

Maurizia Tazartes

PRESTEL

Munich · London · New York

Front cover: *Girl with a Pearl Earring*, c. 1665, Mauritshuis, The Hague (detail), see page 93
Frontispiece: *Head of a Young Woman*, c. 1666-1667, Metropolitan Museum of Art, New York (detail), see page 101
Back cover: *The Milkmaid*, c. 1658-60, Rijksmuseum, Amsterdam (detail), see page 59

British Library Cataloguing-in Publication Data: a catalogue record for this book is available
from the British Library; Deutsche Nationalbibliothek holds a record of this publication in the Deutsche
Nationalbibliografie; detailed bibliographical data can be found under: http://dnb.d-nb.de

The Library of Congress Number: 2012939405

Prestel Verlag, Munich
A member of Verlagsgruppe Random House GmbH

Prestel Verlag
Neumarkter Strasse 28
81673 Munich
Tel. +49(0)89 4136 0
Fax +49(0)89 4136 2335

www.prestel.de

Prestel Publishing Ltd.
14–17 Wells Street
London W1T 3PD
Tel. +44 (0)20 7323-5004
Fax +44 (0)20 7323-0271

Prestel Publishing
900 Broadway, Suite 603
New York, NY 10003
Tel. +1 (212) 995-2720
Fax +1 (212) 995-2733

www.prestel.com

Prestel books are available worldwide. Please contact your nearest bookseller or
one of the above addresses for information concerning your local distributor.

Editorial direction: Claudia Stäuble, assisted by Franziska Stegmann
Translation from Italian: Bridget Mason
Copyediting: Chris Murray
Production: Nele Krüger
Typesetting: Andrea Mogwitz, Munich
Cover: Sofarobotnik, Augsburg & Munich
Printing and binding: Elcograf, Verona, Italy

FSC
www.fsc.org
MIX
Paper from
responsible sources
FSC® C115118

Verlagsgruppe Random House FSC-DEU-0100
The FSC-certified paper *Respecta Satin* is produced
by Burgo Group Spa., Italy.

ISBN 978-3-7913-4743-1

Contents

Introduction

Seventeenth-century Dutch social and cultural life is vividly reflected in its art. Thousands of tiny episodes tell the stories of industrious women in middle-class homes dusting, sweeping, and polishing as they wait for their men to come home; of sedate, far-away landscapes, with children skating happily on frozen winter canals or playing on the streets; of wealthy, slightly corpulent cavaliers, all too ready to give in to the seductive women on tap in the taverns; of absorbed, conscientious craftsmen and professionals engrossed in guild and militia meetings; of bespectacled village doctors tending patients; of crafty peasants and pipe-smoking drinkers; of formal young ladies in their starched headscarves and young servant girls with glowing eyes; of crowded markets, heaving with merchandise and harbors piled high with Oriental spices; and, above all, of clean, well-lit domestic interiors, their features minutely picked out—a forgotten toy on a gleaming floor, laden tables recently vacated and not yet cleared, a twist of lemon peel on a silver platter, fine Chinese porcelain and secretly read love letters. There is always something new to discover in seventeenth-century paintings: light gleaming on pewter or brass, shining window mullions, trim gardens and backyards, blue-and-white Delft-tiled skirting boards, inlaid lavender-scented cupboards containing spotless, carefully folded sheets.

In Vermeer's paintings we also see fruit bowls on windowsills, maps hanging on walls, a broom left abandoned in a corner, a pair of soft, comfortable slippers. In Vermeer, however, such details serve to make vivid the lives of real men and women, with their passion and unspoken longings. Whereas many of the Dutch painters went only as far as the threshold, simply describing the "outward" appearance of the self-satisfied society to which they belonged, Vermeer captured the soul of his subjects. It took very little. Vermeer's poetry lies simply in a complicit look between two women, a smile, a wrinkle etched on a forehead, a sudden smile of recognition. A raised eyebrow, a sketchy gesture, are enough to set up a secret dialogue of emotions and suggestions between the viewer and the people in the paintings. It was Vermeer, undoubtedly the finest interpreter of seventeenth-century Dutch society, who lifted these people to a timeless realm, giving them a universal character. The same can be said of his few yet sublime landscapes, such as the great *View of Delft* at the Mauritshuis in The Hague. The "little patch of yellow wall" that shines out of the painting elicited a famous rhapsodic response from Marcel Proust, when he went to see it in

Paris, muffled up and feverish, and even more ethereal than usual. Like his figures, Vermeer's houses, suffused with gentle light, have souls, melancholy and private when the rain trickles down the tiles, full of hope when the skies clear, the sun shines, and the canals are a radiant blue. Vermeer's life was devoid of epic moments: it was short (he died at the age of forty-three) and punctuated by the births of an almost endless series of children (no fewer than fifteen), official tasks at the painters' Guild in Delft, and short business trips to the surrounding area; and when he died he left huge debts that would force his widow to sell off his paintings in order to settle her debts with the baker. There were no official commissions, only sporadic and indirect contact with the outside world, and very few established dates for his pictures, the chronology of which is often uncertain. It was a simple, retiring life, but Vermeer had several important friendships: first and foremost with Antonij van Leeuwehoek from Delft, the great scientist and inventor of the microscope—their relationship may well hold the key to the visual precision of Vermeer's art. For those with the patience to look attentively, Vermeer's quiet art can provide vivid glimpses of a vanished world of extraordinary charm.

Stefano Zuffi

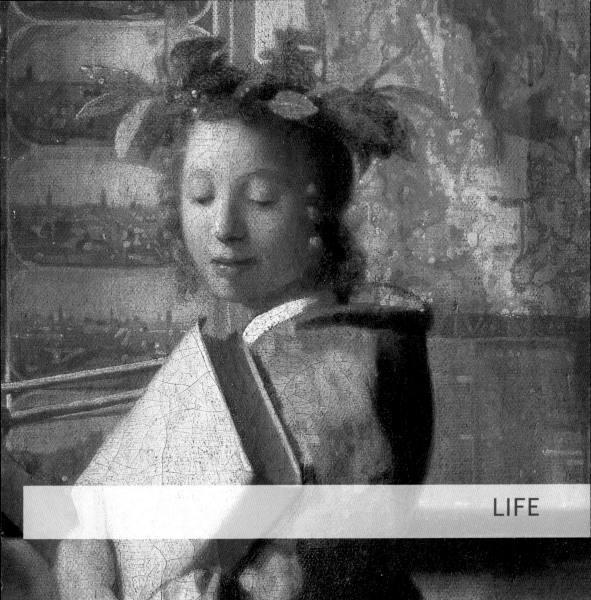

LIFE

The Enigma of Vermeer

In an article for the *Gazette des Beaux-Arts* in 1866, the French critic and writer Étienne-Joseph Théophile Thoré, who wrote under the pseudonym Thoré-Bürger, described Vermeer as the "Sphinx of Delft." And Vermeer is unquestionably one of the great enigmas in the history of art. Few paintings, only thirty or so, have been definitively attributed to him, while another four are doubtful, and few personal documents survive (they were published by Abraham Bredius between 1885 and 1916). Dates on his paintings are few and far between and uncertain at that, their chronology, hinging on stylistic and technical criteria, largely hypothetical.

Fragments of a life

John Michael Montias brought a large number of new archive documents on Vermeer's family and city background to light during the 1970s and 1980s, which he used as the basis for his groundbreaking *Vermeer and his Milieu* (1987). We now know that Vermeer's maternal grandfather was a forger, that his paternal grandfather was guilty of fraud, and that his mother-in-law had separated from her husband in 1641 after a series of quarrels that frequently degenerated into family brawls. Life in Delft is described in minute detail, as are the comings and goings of the artists, their meetings, and the opportunities available to young painters in such a small city, precious snippets of information that stimu-

late further research and conjecture. Vermeer himself, however, remains a mysterious figure. In order to see him more clearly we need to look beneath the surface of his limpid depictions of quiet bourgeois interiors and characters. We need to examine the folds of those magnificent fabrics and drapery, unlock the significance of those silent rooms, the glasses of wine, the musical instruments and everyday objects, all redolent with allegorical meanings that had been a feature of Northern art since the Middle Ages. We need to decipher the few but vital clues that will shed real, practical light on Vermeer's remote and seemingly very private world. His was a short life, dedicated to his slow, methodical painting of small masterpieces, which he worked on day and night, harnessing every conceivable nuance of light; he died at the early age of forty-three. He worked painstakingly, when not performing his various duties for the Guild of Painters in Delft. He had eleven mouths to feed (four of his fifteen children died in infancy), a wealthy and strong-willed mother-in-law, and an art dealership to run; he amassed huge debts, so that when he died his widow, Catharina Bolnes, had to declare herself bankrupt and sell what was left of her husband's paintings in order to pay the baker. He had no official patrons, and only sporadic and indirect dealings with collectors and admirers. He led a simple, retiring life, but had several important friends, such as Anthonij van

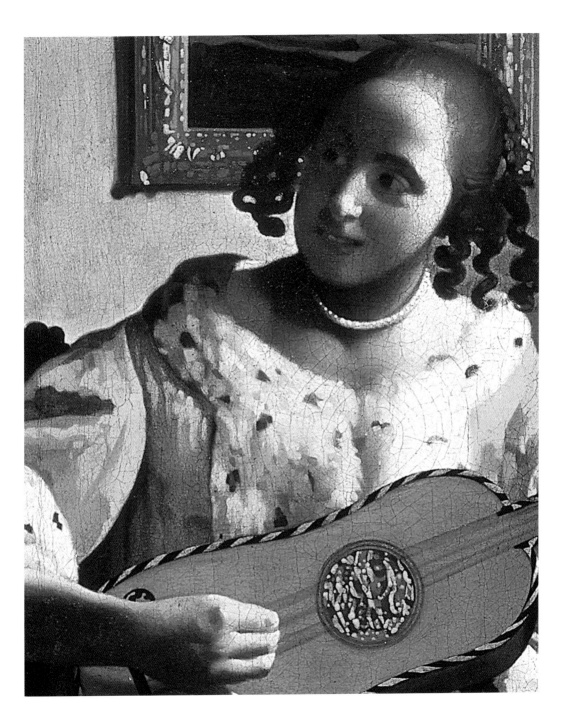

Leeuwenhoeck, the great scientist from Delft, who perfected the microscope and whose optical studies may well have contributed to the magical skills of a great artist capable of capturing the hidden life of everyday things.

Delft 1632–1656

Vermeer's father, Reynier Janszoon Vos (or Vosch), came from a simple family of craftsmen in Delft. He met his wife, Digna Baltens (Dyna or Dimphna Balthasars), in Amsterdam where he had been sent in 1611 as an apprentice *caffa* weaver, *caffa* being a particular sort of silk used for drapery and upholstery. They married in Amsterdam on 19 April 1615, and shortly after moved to Delft, where Reynier had relatives and where their first daughter, Geertruijt, was born in 1620. Delft was a small city, encircled by solid medieval walls, its best-known products being ceramics, textiles, and beer. The houses were packed along the canal, as immortalized by Vermeer in his evocative *View of Delft*. Just a few kilometers from The Hague, Delft was one of the most prosperous cities in the Dutch Republic, also

known as the Seven United Provinces, which became independent of Spanish rule during the Eighty Years' War (1568–1648). Prince William of Orange, *Statolder* of the Provinces of Holland, Zeeland, and Utrecht, led the revolt. He had chosen Delft as his city of residence and was killed there in 1584 by a pro-Catholic fanatic. He was laid to rest in the Nieuwe Kerk (New Church) in Delft, in a splendid tomb designed by Hendrick de Keyser and completed in 1623. The city was known for its towers, its churches with their slender gothic spires, its canals, its windmills, and what the burgomaster Dirk van Bleyswijck, in his *Beschrijvinge der Stadt Delft (Description of the Town of Delft)* of 1667 described as "the finest, most elegant and spacious houses in all the Netherlands." It was known for its beer, despite a falling-off in production due to the fact that the southern provincial market had remained under Spanish rule, and the city continued to produce pottery, fabrics, and paintings to sell to the conservative bourgeoisie. The well-run Guild of St Luke included painters, master glassmakers,

engravers, sculptors, potters, weavers, book-sellers, and publishers among its members. The city had around 20,000 inhabitants in the 1630s, including Reynier and Digna, the future parents of Vermeer. Life did not prove easy for them—they owed money to her father and were plagued by legal battles after a fight in which Reynier had dealt a mortal blow to a soldier. Registered as a weaver, Reynier changed tack in 1630, when he decided to become a publican, a job that paid well thanks to the proliferation of visitors to the city. He rented a tavern, *De Vliegende Vos* (The Flying Fox), overlooking the Voldersgracht canal that ran along the market square in the city center. Business was brisk, and on 13 October 1631, Reynier joined the Guild of St Luke in Delft as an art merchant, organizing auctions and sales of art at the tavern. By 1641, he was wealthy enough to buy another tavern, right on the market square. He named it *The Mechelen*, after the city from which his family had originated, and carried on selling paintings there. On his death in 1652, he left the business to Johannes Vermeer, known simply as Jan, his second born and first male child, baptized on 31 October 1632 in the Nieuwe Kerk. The surname Vermeer, common among his contemporaries, certainly derived from Reynier, who had signed himself "Vermeer" in 1640.

Apprenticeship

There is not a shred of information relating to Vermeer between his birth in 1632 and the 5 April 1653, when he appeared before a notary for the publication of the banns for his marriage to twenty-two-year-old Catharina Bolnes, who was two years older than he and from a wealthy family from Gouda. The witnesses to the wedding included the fifty-eight-year-old painter Leonard Bramer, who was probably related to the Pieter Bramer who had attended Jan's baptism in 1632. The civil wedding was followed by a secret Catholic marriage ceremony on 20 April in the nearby town of Schipluy (today Schipluiden), Vermeer having apparently converted from Calvinism earlier. Catharina had moved to Delft in 1641 with her mother Maria Thins, who had left her husband because of his cruelty, taking two daughters with her and leaving her son Willem with his father. Although Maria Thins never signed a document giving permission for her daughter's wedding, she made no formal objection to the marriage, and seems to have got on well her son-in-law. Nothing is known of his training or his early working life; he may well have worked in his father's inns, first on the Voldersgracht and then at *The Mechelen*, helping his father while also preparing for his future career as a painter. Both his parents were over forty by the time he was born in 1632 and had insisted on their children going to school and learning a "suitable trade." Hypotheses about Vermeer's apprenticeship abound, and include a period of study in Amsterdam in the studio of Rembrandt: there are echoes of the latter in Vermeer's oeuvre but they are faint. Another theory, proposed in the 1990s by John Michael Montias and Arthur K. Wheelock, Jr., is that Vermeer frequented the workshop of the painter Braham Bloemaert (1566–1651), a

distant relative of his wife's and an exponent of a Mannerist style far-removed from his own vocabulary. This theory rests on three paintings that during the 1930s were attributed to Vermeer's early period; it was dismissed by scholars such as Erik Larsen (1996), and appears unconvincing, though it has long been a subject for discussion among art historians. These three works are *St Praxedis*, *Christ in the House of Martha and Mary*, and *Diana and her Companions*, works that in terms of format, technique, subject, and style do not sit easily with Vermeer, requiring the proponents of this theory to perform summersaults to explain the "subsequent change" in the signature style of his authentic works. Large paintings, and of religious and mythological subjects, they are very unusual for Vermeer, and there is no documentary evidence that he painted religious or "historical" pictures in his youth, particularly not large ones. The one exception may be a work referred to as "*Visit to the Tomb* by Van der Meer – 20 Guilders," which was said to have been in the possession of the art dealer Johannes de Renialme in June 1657; it is not known, however, which "Van der Meer" this relates to, as there were at least six painters of that name working in Haarlem, Utrecht, and other cities. The signatures and dates of all three paintings, which in themselves do not form a particularly homogeneous group, also appear doubtful. Erick Larsen, for example, who had occasion to examine the signatures and paintings in 1948–1949, thought them decidedly spurious. The Italianate character of *St Praxedis*, of which an exact copy dating from 1645 by the Italian painter Felice Ficherelli is preserved in the Fergnani collection in Ferrara, might suggest that Vermeer went to Italy before 1652, but again there is no evidence of this. We do know, however, that the better-known Johan van der Mer of Utrecht (1630–1688) went to Italy in 1655. The three paintings are characterized by disjointed lighting effects, blurred outlines, sketchy backgrounds—all worlds away from Vermeer's subtle *velatura* (semi-opaque glazes) and still, subdued lighting.

Instead of training in Amsterdam or Italy, it would make more sense for him to have studied painting in Delft itself, where his father, a member of the city Guild, ran a prosperous art dealership, which on his death in 1652 he bequeathed to his son, who was then twenty-one. Vermeer may well have made short trips to Amsterdam and Utrecht to keep himself abreast of developments, but there was no lack of artists and painters in Delft, who were in direct touch with more important centers. On 29 December 1653, Johannes Vermeer too was enrolled as a master painter in the city Guild of St Luke, paying a deposit of one guilder and 10 stuivers; it was three years later, on 24 July 1656, that he made his final payment. Vermeer's artistic education must have begun some time before that, for Guild rules required members to have served a six-year apprenticeship before being enrolled, though these rules were not always followed to the letter. Vermeer's first master may well have been his father. Reynier was a fabric designer as well as a skilled *caffa* weaver, and must have introduced his son to the art of drawing and taught him to appreciate the textures and lus-

ters of fabrics. It is clear from some of his early known works, such as *A Maid Asleep*, that the depiction of fine fabrics and carpets was not a matter of luck but born of a consolidated knowledge of fabrics. One of the family's neighbors on the Voldersgracht was Cornelis Daemen Rietwijch (c. 1590–1660), a portraitist and Guild member, who ran an art school of sorts. Montias believes that he may have taught Vermeer the rudiments of drawing. This is entirely possible; on the other hand, Reynier knew several painters to whom he might well have introduced his son, including Delft artists Leonard Bramer (1596–1674) and Willem van Aelst (1627–c. 1683), the latter specializing in fine still lifes executed with technically superior materials and extraordinary plays of light on metal surfaces. Vermeer would undoubtedly have seen and appreciated their work, and might even have studied under one or other of them for a while. Paintings in a wide range of different styles and with many different subjects changed hands in his father's tavern, and may well have fascinated and inspired the young Vermeer, who was later to encounter a great deal more in his mother-in-law's house; Dirck Baburen's *The Procuress* (c. 1662, Museum of Fine Arts, Boston) for instance, which appears in the background of two of his paintings. It is clear that Vermeer would have had a proper painting master. Could it have been the Leonard Bramer of Delft who witnessed his marriage? There is nothing to confirm this; furthermore, Bramer, who studied under Rembrandt in Amsterdam, painted small dark pictures and large frescoes, a somewhat unusual combination.

The Little Street (detail), c. 1657–1658, Rijksmuseum, Amsterdam

Montias's research has also thrown up another name, which could well be the right one: Gerard ter Borch (1617–1681), the most famous and esteemed painter of genre scenes of the haute bourgeoisie. On 22 April 1653, two days after his marriage, Vermeer and Gerard ter Borch were together in Delft, signing a guarantee agreement before the notary Willem de Langue. This was ter Borch's first known appearance in Delft, and the fact that he was with Vermeer might be the key to an earlier relationship, as Montias surmises. Borch, then thirty-six, and referred to respectfully by the notary as "Monsieur Gerrit ter Borch," was at the peak of his career, painting middle-class interiors similar to the ones Vermeer was to paint himself in the mid 1650s: elegant rooms, rarefied atmospheres, gentlewomen in rustling silk dresses, gallant conversations, and recurring themes (love letters and lovers' trysts, music lessons,

The Milkmaid (detail), 1658–1660, Rijks-museum, Amsterdam

portraits), works which focused on the subtle psychological meaning of a scene. Fifteen years older than Vermeer, the artistically refined ter Borch, who had studied under Rembrandt in Amsterdam and the landscape artist Pieter Molijin in Haarlem, and who had been among Caravaggio's followers in Utrecht, had travelled widely in Europe. He returned in 1644 and set up home in Amsterdam in 1648 before spending a year in The Hague (1652–1653), only an afternoon's journey from Delft, where he is known to have been in April 1653 and where he may well have remained until his move to Deventer in 1654. It is therefore possible that Vermeer may have frequented his workshop in The Hague or in Delft for a while, later inviting him to his wedding and introducing him to his own notary, de Langue. It was a good opportunity for "Monsieur Gerrit" to expand his client base.

Carel Fabritius (1622–1654), a brilliant disciple of Rembrandt's, also had considerable influence on Vermeer. Documented as having been in Delft in 1650, he may well have been there prior to that; he died young in 1652, in a gunpowder explosion. His small *View of Delft* (National Gallery, London), signed and dated 1652, has no direct connection with the one Vermeer painted some seven years later, but sets an interesting spatial precedent. Fabritius used strict perspectival rules to ennoble his genre painting, as did other painters in Delft specializing in architectural subjects, such as Gerard Houckgeest (1600–c. 1661) and Emanuel de Witte (1617–c. 1692). A taste for architecture is a typical feature of paintings of interiors and of Vermeer, whose con-

temporaries saw him as the successor to Carel Fabritius, about whose death Arnold Bon wrote this stanza in 1667: "*Thus did this Phoenix, to our loss, expire, / In the midstand at the height of his powers, / But happily there arose out of the fire / Vermeer, who masterfully trod in his path.*" A subsequent version replaces the final phrase with "*Vermeer, who masterfully emulated him.*" The bare, luminous walls in the works of Fabritius, such as in *The Goldfinch* (1654, Mauritshuis, The Hague), recur in Vermeer's interiors, proving that he had found excellent masters in his own city of Delft.

Paintings of interiors in and around Delft

Vermeer's chosen genres, bourgeois interiors and the occasional landscape, were greatly sought-after on the Dutch market from the sixteenth century onwards. They were certainly a cut above the "pictures of beggars, bordellos, taverns, tobacco smokers, musicians, dirty children on their pots, and other things more filthy and worse," as the artist Gérard de Lairesse described the unruly rustic and rowdy scenes in his *Groot Schilderboek* (*Great Book of Painting*) of 1707. Vermeer's paintings were altogether more refined, and proved agreeable to Lairesse, who himself tended to depict interiors with a small number of people having a glass of wine, playing music, or quietly conversing, a genre not entirely correctly defined as "merry companies" or "conversation pieces." Often a female figure, either alone or accompanied by a gentleman or servant, dominates the scene, playing an

instrument, writing letters or examining jewelry in front of a mirror. Everyday life, with hidden allegorical meanings, in well-constructed spaces in which light plays a fundamental role in defining the relationships between the figures, seems to have been a well-defined trend during the 1650s and 1660s among Delft painters, who probably all knew and influenced each other.

As well as Fabritius, Vermeer, and probably ter Borch, there were other masters working on the same sort of paintings, notably Pieter de Hooch (1629–1684), who had moved to Delft in 1652 and joined the city Guild in 1655. He painted courtyards and interiors with doors opening into other rooms, perspectively complex and precise, and typically featuring a majolica floor. He painted fifty or so glimpses of daily life, peopled with busy female figures, before leaving for Amsterdam in 1661. Their subtle spatial approach and their rendering of light made De Hooch and Vermeer the most skilled painters in Delft. They were certainly in touch with each other and dealt with similar subjects, but their approaches were wholly different: Vermeer's protagonists were placed in the corners of rooms, while de Hooch painted rooms in their entirety; Vermeer concentrated on light from one single viewpoint, while his colleague played subtle games with light inside his spaces; Vermeer tended towards synthesis while de Hooch subtly described every detail, according to Flemish tradition; and, above all, while de Hooch did little more than capture scenes of Dutch life, Vermeer managed to express the feelings and the states of mind of his subjects.

There was also Jan Steen (1626–1679), a painter from Leiden, who moved to Delft in the early 1650s and opened a brewery. In Delft he foreswore the chaotic, rowdy scenes he had painted in Haarlem, Leiden, and The Hague in favor of more contained pictures featuring scenes from everyday life set in limpid, luminous outlying towns, such as *The Burgomaster of Delft and his Daughter* (1655, Penrhy Castle, Wales). Nicolaes Maes (1634–1693), who was born in Dordrecht, appears to have been living in Delft during the early 1650s, after leaving Rembrandt's studio and prior to moving back to Dordrecht. He painted genre scenes and silent interiors with female figures caught up in musical or other activities, such as *Girl at the Window (The Daydreamer)* and *A Woman Spinning* of (both mid 1650s and both Rijksmuseum, Amsterdam), works exuding the same sort of tranquility as is found in Vermeer's work. There were other artists, in different parts of the country, working on this same sort of refined genre painting, often for private patrons rather than the general market. Gabriel Metsu (1629–1667) was active in Leiden and Amsterdam, crafting sophisticated plays of light, as in *Young Woman Writing Music* (1662, Mauritshuis, The Hague), *Man Writing a Letter* (1662–1665), and *Woman Reading a Letter* (1662–1663); the last two paintings, now in the National Gallery of Ireland in Dublin, are clearly influenced by Vermeer and show that Metsu was familiar with the Delft School. Gerrit Dou (1613–1675), born in Leiden, where he had frequented Rembrandt's workshop between 1628 and 1630, also painted bourgeois interiors, such

as *The Dropsical Woman* (1663, Louvre, Paris), in which a doctor is scrutinizing a flask containing his patient's urine in order to discover what ails her. This is a typical *Piskijker* (physician, quack) scene, like those produced during the second half of the 1650s by Metsu, his pupil Frans van Mieris, and other painters.

Vermeer's early works: 1656–1660

On the death of his father, Vermeer inherited both the art dealership and the management of the tavern, the latter being a field in which painters were quite often involved; Jan Steen, for instance, kept an inn called *De Slange* (The Serpent). Vermeer had also inherited some of his father's debts, such as the 250 guilders for which he and his wife Catharina had acted as guarantors in front of Rota, the notary, on 14 December 1655. In 1657, he was forced to ask the wealthy bourgeois Pieter Claesz. van Ruijven to lend him 200 guilders to pay off the interest on the loan. Vermeer was living at *The Mechelen* at the time, where his first daughter was born in 1654, and it was during that period that he worked on the interiors, landscapes, and portraits known with certainty to belong to the slender corpus of his early work, documented at the time, stylistically homogeneous, and unanimously accepted by art historians.

One of his earliest surviving works is *The Procuress*, signed and dated 1656. Documented from the mid eighteenth century onwards, the painting caused some doubt among art historians because of its raucous tone and exaggerated expressiveness, quite at odds with the characteristic Vermeer, as is its shallow perspective. If it is indeed an autograph

The Glass of Wine (detail), 1659–1660, Gemäldegalerie, Berlin

work, as it seems to be, it is faintly coarse, despite the finely rendered rug in the foreground and the elegant pitcher, glasses, and fabrics. The theme is a frequent one in Dutch painting, and is rife with allegory, possibly alluding to the temptations besetting the Prodigal Son: the young man, seen with the compliant girl, the elderly procuress, and a young musician, is wasting away his inheritance in a bordello. It is possible, though unlikely, that the work contains an incisive autobiographical note, given that the features of the procuress could be those of Vermeer's mother-in-law, Maria Thins, while the musician may resemble the painter himself. His painting *A Girl Asleep* (previously known as *A Drunken Maid Sleeping*) is from the same period; once owned by Jacob Dissius, it was later sold with another twenty paintings by Vermeer at auction in Amsterdam on 16 May 1696. The painting can be dated to around 1656, and is already redolent of his characteristic style, with well-defined spaces, few figures, fine, richly decorated fabrics, a silent almost enchanted atmosphere, and a subtle, carefully calculated play of light. It is of a type similar to contemporary works by

*Woman with a Pearl
Necklace (detail),
c. 1664, Gemälde-
galerie, Berlin*

Nicolaes Maes and Gabriel Metsu, and has
the same melancholy mood of Carel Fabri-
tius's *The Goldfinch*. It provided a setting that
Vermeer was to use from then on: a scene
set in the corner of a room lit by a window on
the left. The motif of wine, one of his most po-
etic, was a device to which he frequently re-
sorted, as an aside to conversations, musical
pieces, and scenes of seduction showing
smiling gentlemen and young women sipping
from wineglasses or holding carafes, without
ever going too far, as for example in Gerard
ter Borch's *A Gentleman Pressing a Lady to
Drink* (c. 1660, Royal Collection, Britain). Dur-
ing the period 1656/1657–1660, Vermeer
painted another three masterpieces based
on the wine motif in which the allegorical
meanings typical of Northern art are tem-
pered to suit more graceful and elegant
"modern" sensibilities. These pictures, which
suggest that Vermeer was in touch with Pieter
de Hooch, who started painting similar scenes
in 1655, and familiar with his work, are evi-
dence of a steady progress in the use of thick,
luminous pigments and a more accentuated
treatment of light. With their limpid checkered
floors, elegant leather chairs, mirrors, maps,
and pictures on the walls, the rooms may
well derive from Vermeer's new home, which
actually belonged to Maria Thins, in the
Catholic enclave of Delft known as Papen-
hoek, or "Papists' Corner," on Oude Lange-
dijck near the Market Square. Serious finan-
cial troubles had forced Vermeer and his wife
to move in with her mother during the 1650s.
The exact date of their move is unknown, but
we do know that one of Vermeer's children,

recorded as living on "Oude Langedijck," was buried in the Oude Kerk on 27 December 1660. Maria Thins helped to keep the family going by providing a large, comfortable home. Described in the inventory drawn up in February 1676, two months after Vermeer's death, the habitation consisted of an entrance, a "great hall," a dining room, a room on the ground floor, and on the first floor a large studio in which he painted and bought and sold pictures. It would have been similar to the artist's studio Vermeer depicted in *The Art of Painting*, with chairs, a table, masks, fabrics, and costumes, as well as all the objects detailed in the inventory: palettes, paintbrushes, stones for grinding paints, and books. The painting *Girl Reading a Letter at an Open Window*, just slightly later than *A Maid Asleep*, introduces another motif dear to Vermeer and other painters of his time: the love letter written or read by a girl or young woman, alone or in the presence of a servant. Vermeer was to paint at least six canvases based on this theme during the subsequent twenty years, capturing various stages of the reading or writing as if in a series of film shots; the protagonists are probably portraits of women in his family, maids, or relatives of his patrons. Gerard ter Borch's *Woman Writing a Letter* (c. 1655, Mauritshuis, The Hague) tackles the same subject, as does his *Woman Sealing a Letter* (c. 1659, private collection). But Vermeer goes beyond the narrative to achieve a timeless dimension. It is exactly this atemporal, and therefore universal, quality that makes his figures stand out, compared with those of other contemporary painters. *The*

Milkmaid, generally dated 1658 to 1660, for example, shows a traditional kitchen scene transformed by a downtrodden goddess, clothed in lowly rags. The stale and fresh bread, earthenware vessels, a woven basket, and a foot warmer are bathed in an intense but subtle light that seems to have the power to turn base materials into gold. Vermeer's works epitomize the poetry of silence. Even the busy streets of Delft, immortalized in the two famous townscapes (*A Street in Delft* and *View of Delft*), are so quiet that one can almost hear the soft splash of the water being used by the maid in the courtyard or the distant murmur of conversation.

Later masterpieces and illustrious visitors: 1660–1670

Vermeer's world was entirely focused on his painting, concentrated and silent, while his noisy and unruly family revolved around him. In 1660 another problem came to plague the already complicated life of his mother-in-law Maria Thins, in the shape of her son Willem, whose father could no longer keep him. The boy led a dissolute life and in 1663 had threatened his mother and sister Catharina, then in the later stages of pregnancy. Some of the family's neighbors, who had come to the women's aid, reported the turbulent goings-on to a notary. The lad was then sent to a private remand home, from which he is said to have escaped with one of the maids, creating yet more problems. Vermeer never appears on the tumultuous family scene. We are left to imagine him painting away in his studio, working on pictures for his patrons, busy sell-

ing paintings for other people, or at the Guild, where he was a person of some standing. Little is actually known of his activities, however. We do know that he acted as guarantor for a loan of 78 guilder to one Clement van Sorgen in 1661, and that he was twice elected Dean of the Guild, on 18 October 1662 and again on 18 October 1670. These events testify to the respectability that Vermeer had acquired in the eyes of the citizens of Delft. Several precious snippets from the 1660s reveal that Vermeer had also become quite well known elsewhere, in cultured and elegant circles. In 1663 Balthasar de Monconys (1611–1665), an erudite French diplomat and connoisseur of art made it his business to call on local artists during a trip to the Netherlands. He had met Gerrit Dou and Frans Mieris in Leiden, Anton Delorme in Rotterdam, and other artists in other cities. He visited Vermeer's studio in Delft on 11 August, later noting in his journal: "On 11 August 1663 I saw the painter Vermeer who did not have any of his works [in his studio]: but we did see one at a baker's, for which six hundred livres had been paid, although it contained but a single figure, for which six pistoles would have been too high a price."

Clearly he had not been particularly impressed by Vermeer's work, but the episode does confirm the reputation the artist had achieved. Recent studies claim that the baker, certainly Hendrick van Buyten (1632–1701), had paid the same price of 600 livres for Vermeer's painting as Gerrit Dou, an extremely well-respected artist, had asked of Monconys during the same period for *A Woman at a Window*, also a work with only one figure; Frans van Mieris the Elder (1635–1681), however, was asking no less than 1,200 livres for a more elaborate painting. Vermeer is also mentioned in Dirk van Bleysweyck's *Description of the Town of Delft* of 1667, although the latter does not offer any opinions. On 14 May 1669, Pieter Teding van Berckhout recorded in his diary visits to the studios of Cornelis Bischop, Caspar Netscher, and Gerrit Dou, and to that of "a celebrated painter named Vermeer" on a couple of occasions, "who showed me some examples of his art, the most extraordinary and most curious aspect of which consists in the perspective."

It was clearly Vermeer's rendering of space that most impressed his contemporaries. He produced his greatest masterpieces between 1660 and 1675, which he painted slowly, probably for private clients. The motifs are typical and recurrent: music, pearls, letters, and lacemaking, while light remains a fundamental element of the construction of his works, the way it glanced off things and people, its gleam on fabrics and colors, its gentle contrast with shadows, which are never dark. He always painted the same settings, his treatment perspectivally skilled from various viewpoints never monotonous. These were tranquil bourgeois interiors containing female figures, their gestures and characters sensitively rendered, for which his wife Catharina is believed to be the model, transformed into a delicate fair-haired woman, reading letters or documents by the light of an elegantly paned window; looking at herself and her pearl necklace in the mirror; weighing pearls or gold; playing the lute or embroidering, often

wearing a yellow jacket tipped with fur at the wrists and neck. Other female figures appear in Vermeer's gynaeceum: his mother-in-law perhaps, or his daughters, wearing turbans, pearl earrings or disguised as allegorical figures, in the manner of Rembrandt. Any attempt to identify them would entail comparing their birth dates with the chronology of his works, but the conclusions would be merely hypothetical. We may well try, for example, to identify the sad-looking housewife steadying a brass pitcher in the corner of a room with pale walls on which a map is hung—but we might lose some of the poetry. *The Young Woman with a Water Pitcher*, thought to have been painted between 1664 and 1665, is one of Vermeer's most sophisticated works, rendered in yellow and blue tones: few objects, a single figure, perspectively accomplished and bathed in gentle light that streams in through a window and plays with equally gentle shadows. It would also be interesting to know the identity of the figure in *Woman in Blue Reading a Letter* in a room lit by an unseen window. Her long blue jacket fails to disguise the fact that she is pregnant. But what really

strikes one are the extremely sophisticated colors, the sparse, carefully arranged furnishings, and the magical atmosphere. Beribboned women playing the virginals, chandeliers, paintings, and earrings: Vermeer paints or creates harmonious and beautiful worlds unlike those of any other sixteenth-century Dutch artist. The pensive expression of the figure in *A Lady Writing* is unique, her hand resting delicately on the desk, beside a pearl necklace; while the woman in *Lady Writing a Letter with her Maid* is writing with such gusto that one can almost hear the scratch of pen on paper in the silence of the room, with the maid standing by. And what about *The Lacemaker*? The woman is concentrating on her work, bent over the mesmerizing colored threads, sighing gently. Vermeer also painted male figures, although much less frequently: the gentleman with the woman drinking wine or the virginals-player, for example. These figures in "conversation pieces" were typical of what Jan Sysmus, an Amsterdam surgeon, described as *jonkertijes* (small gentlemen) in his list of "modern" painters. In Vermeer's paintings, these nattily dressed

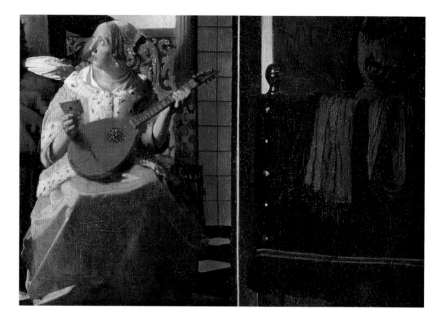

men conserve a measured presence even in racier works such as *The Girl With Two Men*.

The gentleman in the elegant cloak, offering a glass of wine to the woman in the headscarf in *The Glass of Wine*, keeps a respectful and faintly admiring distance from the "young lady." This is worlds away from Gerard ter Borch's *A Gentleman Pressing a Lady to Drink*, with his heavy hand on the woman's shoulder, grasping the bottle, against the dark background of an imaginary tavern. Compared with Vermeer's composed gentlemen, similar figures by Frans Mieris the Elder or Dirck Hals have a thuggish look. Vermeer stood out from his contemporaries in the subtly rendered balance between the scene being represented and its setting, as, indeed, did Pieter de Hooch and Gabriel Metsu.

Hard times: 1670–1675

Vermeer's mother died in her house on Vlaminstraat on 13 February 1670, and a few months later, on 13 July, Vermeer took full possession of *The Mechelen*, which had been mortgaged and earned a small rent. The following year, he inherited 648 guilders from his sister Geertruijt, the equivalent of what a bricklayer could earn in two years, as well as a further inheritance from one of his wife's relatives. In 1672, he let *The Mechelen* for six years at 180 guilders a year to his namesake, Johannes van der Meer, who took possession in May. By this time he had become well known not just as a painter but also as a picture dealer, and it was in this capacity that he was summoned to The Hague in May 1672, along with his colleague and fellow-citizen Johannes Jordaens (1616–1680), who had spent a lengthy period in Italy. The purpose of their journey was to value thirteen paintings, most of them by Italian artists, sold for 30,000 guilders by the dealer Gerard Uylenbourgh from Amsterdam to Friedrich Wilhelm, Elector of Brandenburg, who had dismissed them

as "clumsy copies and tat," an opinion supported by his agent, the painter Hendrick Fromantiou. There were other experts there too, working for both sides. Invited to express his opinion, Vermeer said that the works were not originals by Michelangelo, Titian, and Tintoretto, as Uylenbourgh had professed, but "daubs and bad paintings" that were not worth what had been paid for them. They were in fact workshop paintings, which the Elector managed to return to the dealer, who then put them up for auction in Amsterdam the following year.

Despite various legacies, the rent from *The Mechelen*, and the income from selling his own and other artists' works, Vermeer was far from wealthy, and the family relied on Vermeer's mother-in-law. Clearly his buying and selling of paintings by other artists, of which an inventory of 1676 drawn up after his death survives, did not bring in a huge amount. Furthermore, the dramatic events that overtook the county in 1672–1673, after Louis XIV's French army invaded the Netherlands, looting and wreaking devastation, forced the Dutch to open their water-gates and flood their land, with serious consequences for the country's economy. Vermeer found himself unable to sell either his own paintings or those by other artists, to his wife Catharina's chagrin. Thus his mother-in-law's fortune became increasingly crucial. On being widowed, in April 1674 she had entrusted Vermeer with administrating her legacy from her husband, Reynier Bolnes. A month later, Vermeer went to Gouda to make the more urgent decisions regarding his father-in-law's affairs. He appeared

with Maria Thins in front of a notary in Delft, in connection with another legacy, that of the late Henrick Hensbeeck, related to Reynier Bolnes, who had died in Gouda and left his estate to Catharina and her brother Willem. On that occasion, Maria Thins signed a document fully empowering "her son-in-law, E. Johannes Vermeer, the well-known painter, to represent her in the business of the estate of the late Henrick Hensbeeck," giving him power of attorney. The document was also signed and witnessed by the glassmaker Pieter Roemer. But despite his mother-in-law's help, Vermeer was compelled to take out a loan of 1,000 guilders on 5 July 1675. His pressing financial worries, and the need to provide for eleven children, the youngest not yet two, must have contributed to the sudden heart attack that killed him on 16 December 1675 at the age of forty-three. He was buried in the family tomb in the Oude Kerk. His wife Catharina explained that the war had had disastrous repercussions on her husband's financial situation and that "as a result, and owing to the great burden of his children, having no means of his own, he had lapsed into such decay and decadence, which he had so taken to heart that, as if he had fallen into a frenzy, in a day or day and a half he had gone from being healthy to being dead."

Vermeer's legacy: 1675–1688

Vermeer's death left his family in dire straits. Catharine was forced to sell the assets and pictures left to her by her husband and kept in his studio; an inventory was compiled on 29 February 1676, after the artist's death,

along with an inventory of items left in the rest of the house of Maria Thins, which were to be split equally between Maria and Catharina. Around seventy works were involved, altogether. Some were by Vermeer, three by Carel Fabritius, including two portraits, possibly two works by Samuel van Hoogstraeten, and others by unnamed artists. The list included canvases, tables, paintbrushes, two easels, pigments, and other items. In order to repay the debt of 617 guilders to the baker, Hendrick van Buyten, in 1676 she gave him two paintings by Vermeer, thought to be the *Lady Writing a Letter with her Maid* and *The Guitar Player*, reserving the right to buy them back at 50 guilders a year. We know that the baker, most probably the same one with the expensive Vermeer painting seen by the Frenchman Monconys in 1663, was one of the wealthiest men in the city and had an important collection of artworks which, at the time of his death, included three Vermeers bought before 1683: undoubtedly the two he had obtained from Catharina and the one seen by Monconys. The Vermeer family debt corresponded to the quantity of bread needed to keep the family going for a couple of years. The baker, who had been a friend of Vermeer's, allowed his widow twelve years in which to buy back the paintings by installments.

Their financial situation continued to be precarious, and on 24 and 30 April 1676 Catharina went to the High Court to file for bankruptcy and to ask for a moratorium on the debts left on the death of her husband. The naturalist Anthonij van Leeuwenhoeck,

a citizen of Delft and the same age as Vermeer, famous for his advances in the design of the microscope, was appointed as trustee in bankruptcy. The two men may well have been friends and have worked together, but Leeuwenhoeck behaved harshly towards Vermeer's widow and mother-in-law, accusing them of concealing assets and money from the creditors. After Vermeer's death, Maria had in fact made alterations to her will on several occasions, paring the legacy due to her daughter down to the bare minimum and claiming that all loans taken out to keep the family afloat should be deducted from the sum due to her; thus on Maria's death, all her assets would have gone directly to her grandchildren. For her part, Catharina had entrusted her mother with all the precious items, so that they could not be taken from her, and on 24 February, in an attempt to keep one of her late husband's works still in the studio, she officially made over *The Art of Painting* to her mother, claiming that it was security against the repayment of a debt; later, the executor of the will put the painting up for auction, despite Maria's protestations that the painting belonged to her. However, the repayment of debts with paintings continued. Jannetje Stevens, a cloth merchant, had to be paid: she claimed the proceeds of the twenty-six paintings put up for action by the dealer Jan Coelembier of Haarlem in 1677. The modest sums realized by the paintings in question suggest that they were not by Vermeer, with the exception of *The Art of Painting*, which Maria Thins had claimed was hers.

Times were hard for Catharina, who died

eleven years later, on 2 January 1688, in the house on Verversdijk and who was buried in the Oude Kerk in Delft. Her husband's paintings had been scattered among various collectors. According to reliable calculations, the surviving and lost works cited by sources as having been produced during Vermeer's lifetime must have amounted to between fifty and seventy. Some had belonged to van Buyten, the baker, and others—it has been argued—to the scientist Anthonij van Leeuwenhoeck, the bankruptcy trusee who is thought to have advised Vermeer on the use of the camera obscura. This theory is underpinned by the unusual theme of two of his paintings, *The Astronomer* (1668) and *The Geographer* (1668–1669) both executed in exactly the same vocabulary as the rest of Vermeer's work, but representing particular figures from the scientific world, worlds away from his usual domestic interiors with female figures. Van Leeuwenhoeck himself is thought to have commissioned the paintings, having qualified as a topographer shortly after their completion in 1669. Utterly different from the rest of his oeuvre and possibly originally devised as companion pieces, these depictions of an astronomer and a geographer underscore the powerful connection between the brain and the hand, between science and feeling.

Other works may have belonged to the wealthy landowner and collector Pieter Claesz. van Ruijven (1624–1674) of Delft, although no evidence of direct contact with Vermeer has come to light thus far. We do know from a notarial deed that on 30 Novem-

Lady Writing a Letter with her Maid (detail), c. 1671, National Gallery of Ireland, Dublin

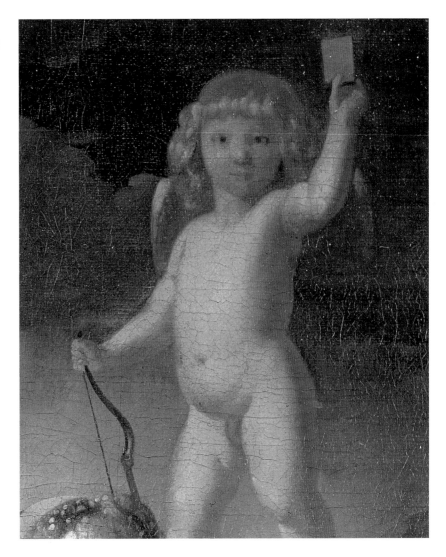

A Lady Standing at the Virginals (detail), c. 1670–1673, National Gallery, London

ber 1657, van Ruijven, who was slightly older than Vermeer, lent him 200 guilders. This is thought to have been an advance for several paintings, and that van Riujven may have been a patron until Vermeer's death. In 1665, a will drawn up by van Ruivjen's wife shows that she intended to leave a sum of money to Vermeer, and van Riujven himself witnessed the will of Vermeer's sister. After van Riujven's death in 1674, and the deaths of his wife and daughter, Magdalena, all the family assets, including an important collection of paintings, went to his son-in-law, Jacob Abramsz. Dissius, a bookbinder. An inventory drawn up in 1683, the year after the death of his wife Magdalena, confirms that, amongst other things, he owned twenty paintings by Vermeer, though their titles are not given.

After Dissius's death in 1695, the paintings in his collection were put up for auction in Amsterdam by the dealer Gerard Houet. Twenty-one of the paintings up for sale on 16 May 1696 were by Vermeer. The list of works and their relative prices, retrieved by Thoré-Bürger, contains many of the works that are now accepted as authentic. The lack of precise documentation means that the acquisition of the twenty-one paintings cannot be attributed to van Ruijven. Some of them, including *Woman with a Pearl Necklace*, even appear to have still been in Vermeer's studio at the time of his death, and cannot therefore have been part of van Ruijven's collection.

It would be over two hundred years before Vermeer's scattered works would form a corpus.

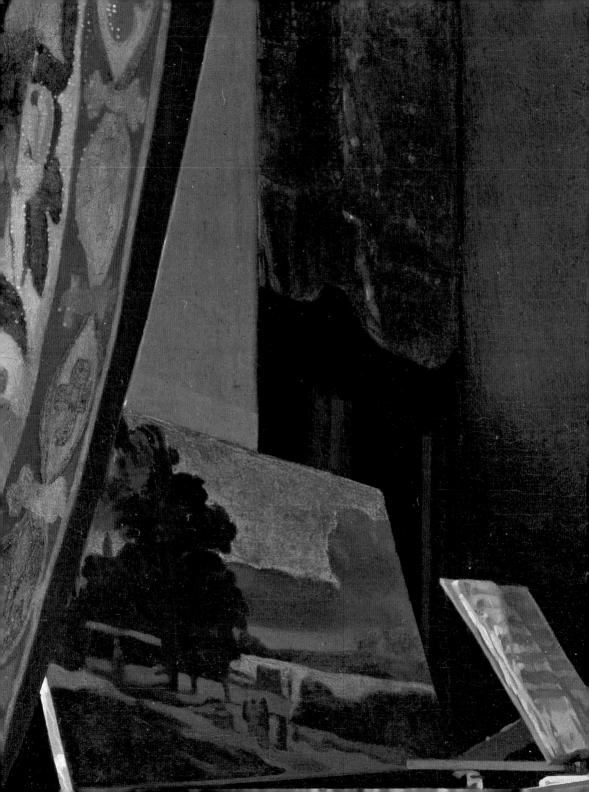

WORKS

Diana and her Companions

c. 1654–1656

Oil on canvas, 98.5 x 105 cm
Mauritshuis, The Hague
Signature, barely legible, bottom left: "J. v. Meer"

Prior to its appearance at the Dirksen Gallery in The Hague in 1866, this painting had been sold to the London entrepreneur Neville Davison Goldsmid for 175 guilders. Listed as No. 68, a work by Nicolaes Maes, it was acquired at the Goldsmid auction in Paris (Drouot) on 4 May 1876 by the Dutch State on behalf of the Mauritshuis, for the exorbitant price of 10,000 French francs, much to the dismay of J. K. J. de Jonge, the Museum's Director, who was not impressed by the purchase. It was catalogued variously under "Nicolas Maes," "Johan van der Meer di Utrecht," and, as of 1901, "Johannes Vermeer," on the basis of its supposed affinity with *Christ in the House of Martha and Mary* in Edinburgh. The reworked fake "Maes" signature on the rock, bottom left, reveals another almost invisible signature in which the Dutch art historian Cornelis Hofstede de Groot saw not a "J" but a "P" or even an "R," while others read it (correctly) as "J. v. Meer," which was very unusual for Vermeer of Delft. There is too little actual evidence, therefore, to support an attribution to Vermeer of a work that is absolutely atypical in both subject and style. There is nothing to suggest that Vermeer ever dealt with mythological subjects, even assuming that there was an underlying religious significance (the washing of feet), as Arthur K. Wheelock, Jr., asserts, given that there are no religious paintings in the documented corpus of Vermeer's work.

The attribution to Vermeer therefore rests on the painting's similarity in style to *Christ in the House of Martha and Mary* in Edinburgh, which would not itself, however, appear to be by Vermeer's hand. Moreover, a close look at both paintings suggests that their proposed affinity is somewhat dubious.

Diana and her Companions is more convincingly seventeenth-century than *Christ in the House of Martha and Mary*, which has a more "modern" feel. Art historians from the eighteenth century onwards have come up with a variety of different authors, such as an artist "of Italian extraction, Titianesque in particular" (Cornelis Hofstede de Groot), Vermeer's father (P. T. A. Swillens), a painter of "stories" with Italian experience (Erik Larsen). A certain resonance with the *Diana and her Companions* (Herzog Anton Ulrich Museum, Braunschweig) painted in Amsterdam around 1650 by Jacob van Loo, a highly regarded artist, has been noted.

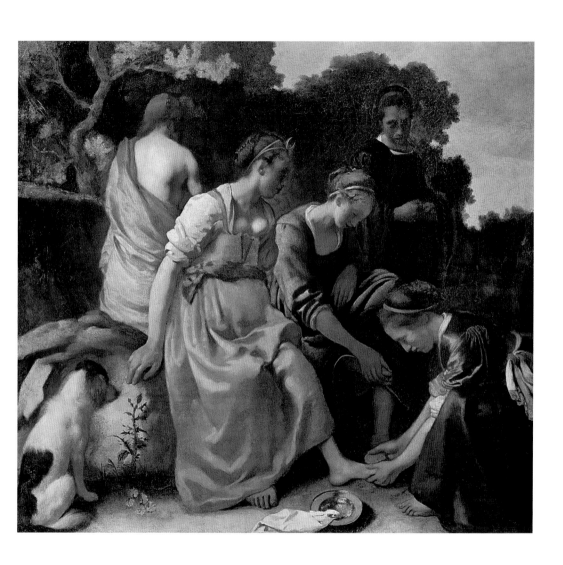

St Praxedis

c. 1655

Oil on canvas, 101.6 x 82.6 cm
Barbara Piasecka Johnson Collection, Princeton
Signed bottom left: "Meer 1655" (?)
and bottom right: "Meer N R[...] o [...]o" (?)

Discovered and acquired at a small New York auction house in 1943 by a Belgian refugee couple, the late Jacob Reder and his wife, the painting went into a private collection in New York on Reder's death, and thence to its present home. It went on show in New York in 1969 under the name of a Tuscan artist, Felice Ficherelli (c. 1605–1669), despite the fact that the signature "Meer 1655" had been attributed to Vermeer by Michael Kitson in 1969. This attribution, which, although supported by Arthur K. Wheelock, Jr., was slow to gain wider acceptance and remains debatable; the same goes for another two paintings tentatively ascribed to Vermeer's early period. The attribution is not based on any historical evidence, merely on its similarity of style to two of his other works, *Christ in the House of Martha and Mary* and *Diana and her Companions*, neither of which can be attributed to Vermeer for the same reasons. The two signatures on the painting are dubious or later, as various scholars, including Erik Larsen, have noted. The style of the painting, treated almost in Expressionist vein with strong contrasts of light and shade, is scarcely compatible with that of Vermeer's established works, which are veiled with a suffused, still light, and the treatment of the background is also different. Furthermore, there is nothing to suggest that Vermeer ever tackled traditional religious or mythological subjects, confining himself to painting interiors, landscapes, and portraits; even his later *Allegory of Faith* is a painting of an interior. For the unsustainable attribution to hold water, Vermeer would have had to have gone to Italy—who knows where—by the time he was twenty years old and painted a copy of a *St Praxedis* dating from around 1645 by Felice Ficherelli (Fergagni Collection, Ferrara). The New York picture is an exact copy of the latter, apart from the additional detail of the crucifix. Unless, of course, the young Vermeer managed to find Ficherelli's painting in some far-flung corner of the Netherlands, assuming it had ever been there. Erik Larsen, however, who examined the New York painting in person in 1948 and 1949, maintains that it is a copy of Ficherelli's work by a minor Florentine artist or possibly an eighteenth- or nineteenth-century fake, like so many flooding the market at the time and not always easily spotted.

Christ in the House of Martha and Mary

1655

Oil on canvas, 160 x 142 cm
National Gallery of Scotland, Edinburgh
Signed and dated bottom left: "IV Meer 1656" (?)

The painting, which suddenly came onto the market in the late nineteenth century, was exhibited by the art dealers Forbes & Paterson of London. It was listed as No. 1 in the catalogue, belonging to Mr William Allan Coats.

It was at that stage that the signature was discovered, causing Abraham Brediu, Director of the Mauritshuis in The Hague, and his Deputy Director, Willem Martin, to prick up their ears. They already had a painting, *Diana and her Companions*, bearing the same signature in their collection that had been doubtfully attributed to "van der Meer"—possibly Johan ver der Meer of Utrecht. It was Bredius who identified the Edinburgh picture, which had been bequeathed as a Vermeer to the National Gallery of Scotland by Coats's son, with the same enthusiasm he was to display forty years later when he attributed a *Christ and his Disciples at Emmaus* to Vermeer that later turned out to be the work of the Dutch forger Henricus Antonius van Meegeren, known as Han van Meegeren. The signature on the Edinburgh picture, which differs from authenticated ones, was the only weak hook on which to hang the attribution to Vermeer of a painting that, according to Pieter T. A. Swillens in 1950, "has nothing in common with authentic works by Vermeer." Neither the large format, nor the choice of an Old Testament subject rather than an everyday one, nor the careless, heavy-handed way in which the paint has been applied, nor that strange, lightly sketched background, could possibly suggest Vermeer, though some of today's scholars have attributed it to him nonetheless. Arthur K. Wheelock, Jr., for instance, while recognizing the difference between this painting and Vermeer's "mature" works, has tried hard to place it in a hypothetical Italianate period, of which in fact there is simply no trace. Another theory is that Vermeer may have been inspired by a painting by the Flemish artist Erasmus Quellinus "during a trip to Antwerp"—an imaginary trip, again. Nor are the lengthy iconographic dissections, which tend towards Vermeer as a painter interested in theology during the early part of his career, convincing. In reality, the work is more like a pastiche, given the many borrowings from other painters, Italian and Flemish, identified by art historians, than an original seventeenth-century work, let alone one by Vermeer.

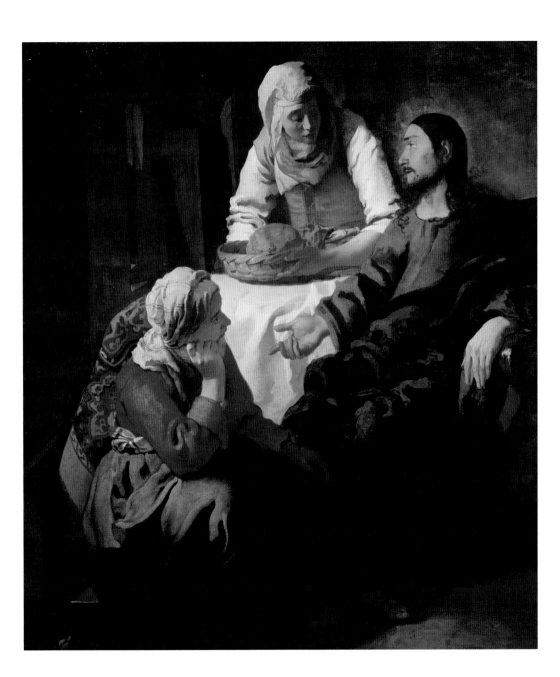

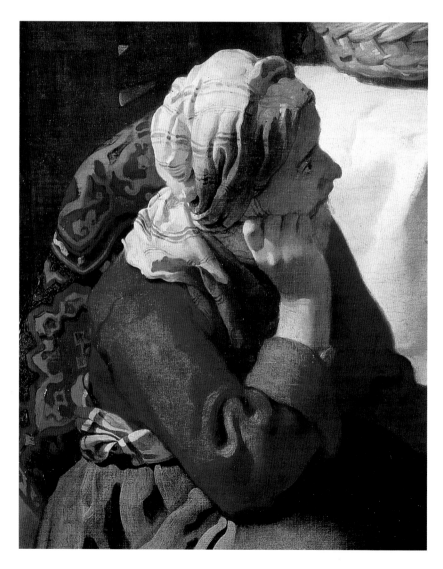

Christ in the House of
Martha and Mary
(details)

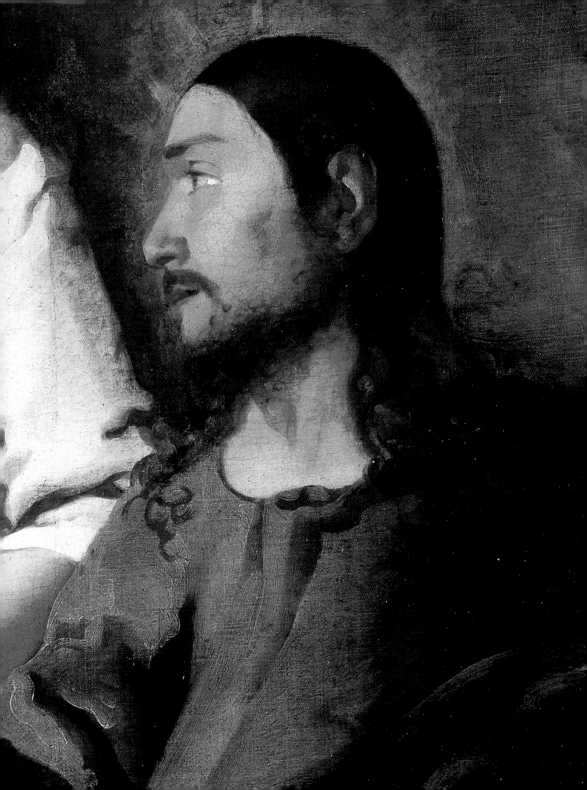

The Procuress

1656

Oil on canvas, 143 x 130 cm
Gemäldegalerie, Dresden
Signed and dated bottom right: "IMeer 1656"

The painting was acquired by the Wallenstein Collection for the Elector of Saxony in 1741. It appeared for the first time as a work by "Jean van der Meer" in the Dresden gallery's catalogue for 1765, with no further information.

In 1782 the artist was given as "Van der Meer di Haarlem," and in 1826 as "Jacques van der Meer of Utrecht." Thoré-Bürger was the first to attribute the painting to Vermeer, in 1860, an attribution that still holds good, although some scholars still dispute it (Erik Larsen, among others). The signature and date are old, though not necessarily contemporary and differ from those on *A Street in Delft*. The subject matter was fairly common in seventeenth-century Dutch painting and Vermeer had access to a painting on the same theme in the home of his mother-in-law Maria Thins. This was *The Procuress* (c. 1662, Museum of Fine Arts, Boston) by Dirck von Baburen, which the painter reproduced in the background of two of his paintings (*The Concert* and *Lady at the Virginals*). Some of the details in the Dresden painting and Vermeer's first safely attributed work, *A Maid Asleep*, are similar: the patterned rug, the wine jug (albeit of a different type), and the young woman's face. Others, however, are completely at odds: the almost total lack of deep perspective in the spatial treatment of the room, and a more narrative approach to the subject, closer to a tavern scene than to Vermeer's elegant interiors. If the work is indeed by Vermeer, as it would appear, it could be one of his earliest, shot through with moral allegory in line with Dutch tradition. The scene represents the evils faced by the Prodigal Son: he is shown dissipating his fortune in a bordello with a compliant young woman, the old procuress of the title, and a young musician.

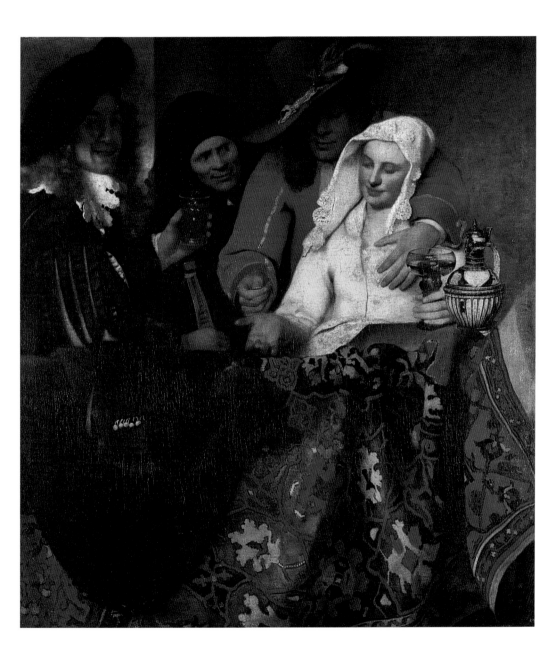

The Procuress (details)

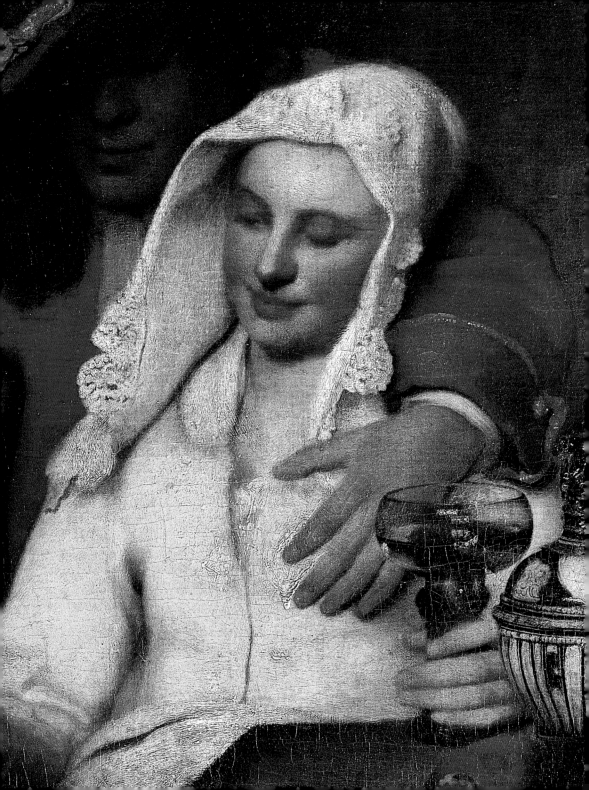

A Maid Asleep

c. 1656

Oil on canvas, 87.6 x 76 cm
Metropolitan Museum of Art, New York
Signed top right: "IV Meer"

This is the first of Vermeer's securely attributed works, sold for 62 guilders at auction in Amsterdam in 1696 as No. 8, "A drunken maid sleeping at a table." It passed through several French collections during the nineteenth century before being bought in 1907–1909 by Benjamin Altman of New York, who left it to the Metropolitan Museum in 1913. The tranquil, elegant middle-class interior features a young woman, undoubtedly a maid, who has fallen asleep after imbibing too much wine, as suggested by the glass on the table near the wine jug, next to a fruit-laden Delft dish.

She is resting her head on her hand, a typically melancholic posture, possibly because of a failed love affair, as the cherub in the painting behind her might suggest. Despite her lowly social status, she is wearing valuable earrings, which would have been beyond her means, as his contemporaries were at pains to point out. The oblique approach to the scene is typically Vermeer, like the fine Oriental rug in the foreground, which is partially rucked up. A partly open door leads into another, sparsely furnished, room, where we see a table, a window, and a painting (or mirror), a spatial device also employed by Pieter de Hooch and Nicolaes Maes. The characteristic Dutch interior contains fine chairs, always a feature of Vermeer's pictures, which also appear on the inventory of the contents of his studio drawn up after his death. A scrap of one of his many maps can also be glimpsed. The perspective is generally well rendered, though possibly slightly tentative in the area between the table and the right-hand chair, which suggests an approximate date of 1656, given the discovery of several pentimenti. Various paintings by Nicolaes Maes may help to unpick the difficult chronology: *The Idle Servant* (1655, National Gallery, London) shows a very similar figure, leaning the other way, and the *Old Woman Dozing* (1656, Musées des Beaux-Arts, Brussels), which differs in terms of iconography, but is similar in terms of atmosphere, along with others by Maes that belong to the same period. Maes was in Delft from 1653 and the two men may well have discussed and shared motifs, compositions, and emblems.

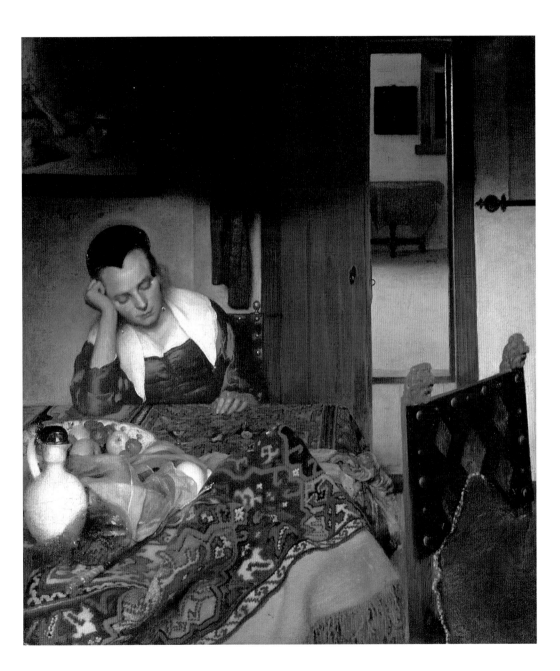

Girl Reading a Letter at an Open Window

c. 1657

Oil on canvas, 83 x 64.5 cm
Gemäldegalerie, Dresden
Traces of a signature bottom right, next to the figure

Initially ascribed to Rembrandt or School of Rembrandt, the painting was acquired by the Gemäldegalerie in Dresden in 1742, along with other works bought in Paris during the rule of the Elector of Saxony, August III. It was correctly attributed to "Van der Meer of Delft" in 1806, and hypothetically identified in 1862 as *Woman Reading in a Room*, item No. 22 in the catalogue of Pieter van der Lip's 1712 Amsterdam auction, selling for 110 guilders. Standing in front of a window, the young woman is quietly engrossed in reading a letter. Her face is reflected in the glass. She is seen in profile, against a pale wall lit from outside on which a picture of a cherub had originally been painted and then removed. There is a fine, leather-backed chair in the corner of the room, and, in the foreground, a table covered with a heavy Oriental rug on which sits a dish of fruit similar to the one in *A Maid Asleep*. It is almost certainly the same room, seen from the window side, which is not shown in the New York picture. A green dust curtain on the right is used to separate the scene from the viewer, a pictorial device employed by many Dutch masters, while a red curtain is draped over the open window. The treatment of the details is extraordinary, from the woolen fabric of the rug to the specks of dust, the folds of the girl's dress, and the construction of the window. Vermeer's use of light seems more sensitive than ever, uniting all the details while focusing attention on the protagonist. The poetry of the painting lies precisely in the fine, sensitive rendition of the girl's innermost feelings, the imperceptible smile that gives away nothing about the contents of the letter, in the absolute silence of the room.

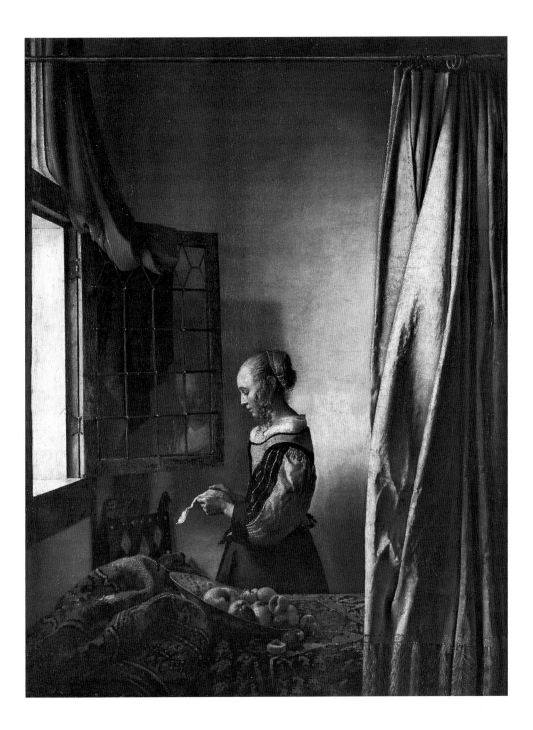

Girl Reading a Letter at an Open Window (details)

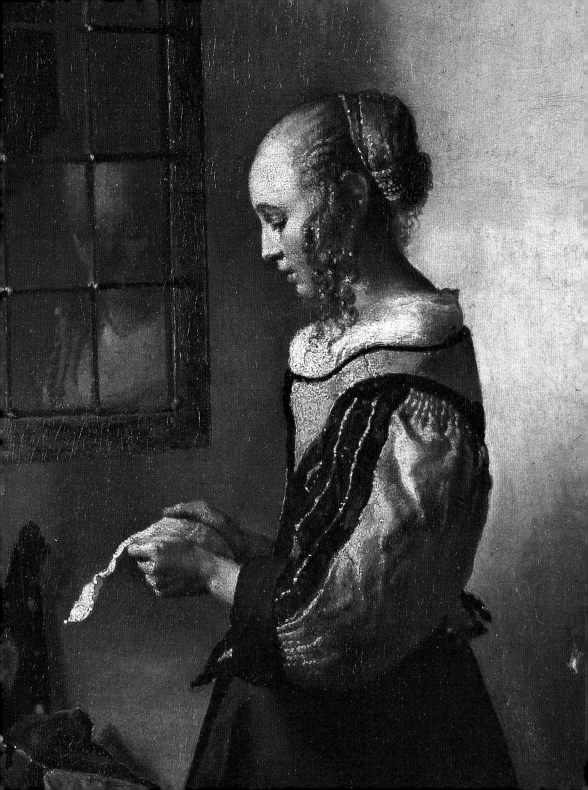

Officer and Laughing Girl

c. 1657–1658

Oil on canvas, 50.5 x 46 cm
Frick Collection, New York

The painting that appeared at auction in London in 1861, ascribed to Pieter de Hooch, and subsequently twice sold in Paris, in 1866 and 1881, is most probably the work by Vermeer described in the 16 May 1696 Amsterdam auction as item No. 11 "A soldier with a laughing girl, very beautiful, by the same [Vermeer]; 44.10 guilders." It is a typical "gallant scene" of a young officer chatting pleasantly to a smiling woman, who is holding a small carafe of wine. Both figures are seated at a table in an interior that closely resembles that in the *Girl Reading a Letter at an Open Window*, with the same perspectival approach, the same window, the same wall with its map of the provinces of Holland and West Frieseland. The device of the map, shown here almost in its entirety for the first time, was to reappear with tiny variations in a further five paintings. The same model is used for the woman as the one in the other painting, wearing the same elegant silk and velvet dress with its broad white collar, though now with her blonde chignon hidden under a white headscarf. The scene, which in this case is more elaborate and developed, suggests a slightly later date. In the foreground, the man's back, elegant hat, and fine cuffs serve to accentuate the spatial depth, and their dark, strong colors contrast with the pale wall. Vermeer may well have used an optical instrument, possibly a simple telescope, in the making of this painting, as the prominence of the officer in the foreground, rather than the female figure in the background, suggest. The weak, golden afternoon sunlight underscores the states of mind of the figures, the merry girl and her composed, complicit courtier.

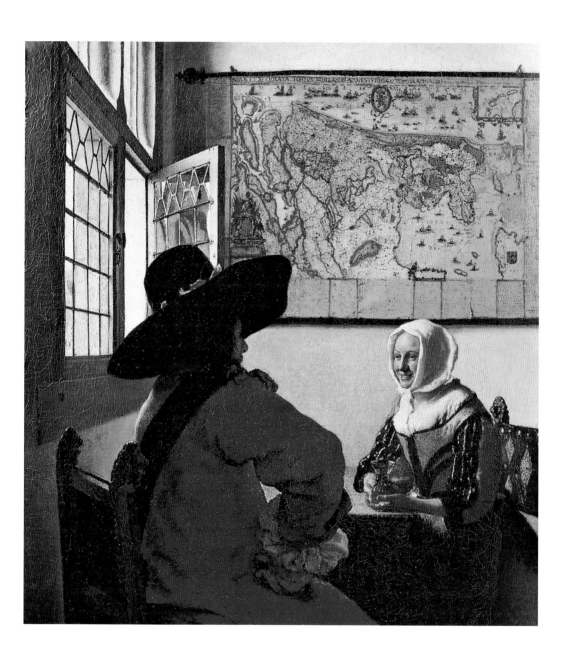

The Little Street

c. 1657–1658

Oil on Canvas, 53.5 x 43.5 cm
Rijksmuseum, Amsterdam
Signed left, below the window: "I V Meer"

This is one of Vermeer's two known views of Delft. It is a small painting, listed in the
Amsterdam auction of 16 May 1696 as item No. 32: "A view of a house standing in Delft,
by the same [Vermeer]' 72.10 guilders." It passed through several different collections in
Amsterdam during the eighteenth and nineteenth centuries. It was bought for the Rijks-
museum for 625,000 guilders in 1921 by Sir Henry William Deterding.
The painting, which has always been much admired, depicts two ancient Delft houses,
with their lead-framed window panes and wooden shutters, linked by two small, bare brick
alleyways; on the patterned paving stones in front of the house on the right, two children,
a boy and a girl, are seen playing. It is not so much a depiction of a place in Delft, with its
endless line of roofs and vines crawling up the walls, as a snapshot of a slice of life,
a moment in time with its own special mood. A tranquil, everyday scene, under a partly
cloudy sky, with two old women going about their business with an air of philosophical
resignation, one sewing by the open door and the other bent over what appears to be a
washtub. A broom leaning against the courtyard wall and the trickle of soapy water are
typical of Vermeer's subtle poetry and extraordinary sensitivity. Pieter de Hooch was also
painting houses and courtyards during the same period, but the descriptive character of
his (admittedly) very fine _Dutch Courtyard_ (c. 1658, National Gallery of Art, Washington),
which shows a chattering group of people drinking and smoking, is quite different from that
of Vermeer's silent, absorbed picture. Some scholars have attempted to identify the houses,
which could be those Vermeer could see from the back of _The Mechelen_, which overlooked
the narrow canal of the Voldersgracht. The right-hand house, possibly a workhouse, was
demolished in 1661 to make way for the headquarters of the Guild of St Luke, so the
painting must have been executed prior to that date.

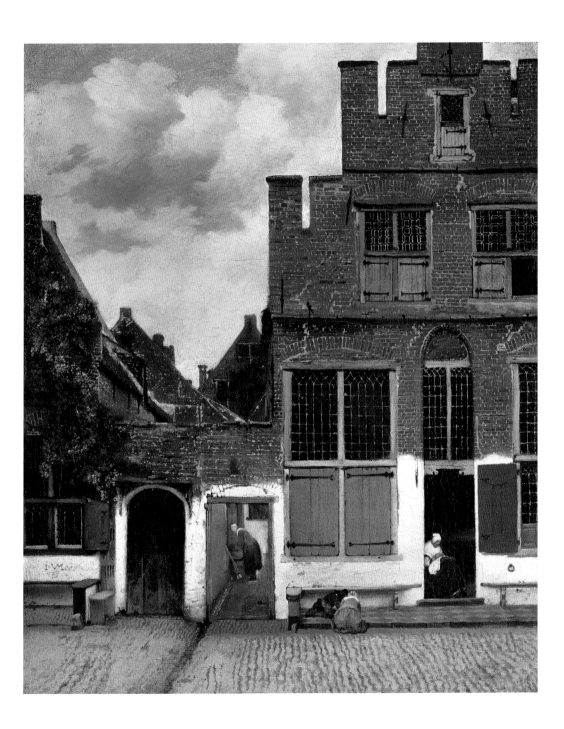

The Little Street
(details)

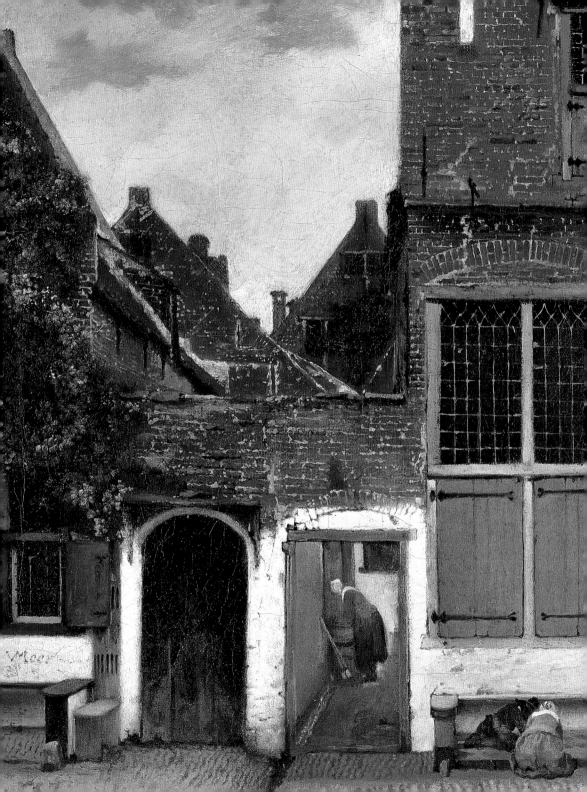

The Milkmaid

1658–1660

*Oil on canvas, 45.4 x 40.6 cm
Rijksmuseum, Amsterdam*

The Milkmaid is generally held to be one of Vermeer's finest works. Listed in the Amsterdam auction of 16 May 1696 as "A maid pouring out milk, extremely well done, by the same [Vermeer]; 175.0 guilders." The painting has remained in the Netherlands, with well-documented changes of ownership; it was in the Six Collection in Amsterdam before being purchased by the Rijksmuseum in 1907–1908.

A fascinating depiction of an unassuming maidservant, seen pouring milk from a jug, the painting represents one of the pinnacles of Western art. The traditional "kitchen scene" genre, portrayed by painters such as Joachim Beuckelaer and Pieter Aertsen during the sixteenth century, had fallen from favor in the Netherlands, apart from in Delft, where it continued to be popular. *The Milkmaid*, however, is a world away from those picturesque and crowded representations. Vermeer has portrayed a single figure, a strong, robust young woman dressed modestly in a rough leather jacket, a blue apron, red skirt, and a white headscarf. She is seen carefully pouring milk into an earthenware bowl, absorbed in her task. On the table next to her there is also some rough bread, making up a splendid still life, rendered with a sophisticated use of *pointillage* (small dots of color). The scene is set in a simple kitchen corner, with light filtering through a window with a broken pane to illuminate the wall against which the figure is silhouetted, a luminous background derived from the works of Carel Fabritius. A foot-warmer stands on the dirty floor, a basket and a brass pail hang on the wall. It has been suggested that the erotic element of the foot-warmer, a symbol of love by virtue of the heat it gives off, is echoed by the cupids on the tiles lining the skirting-board. X-rays have shown up numerous pentimenti, including a map painted on the back wall, later removed.

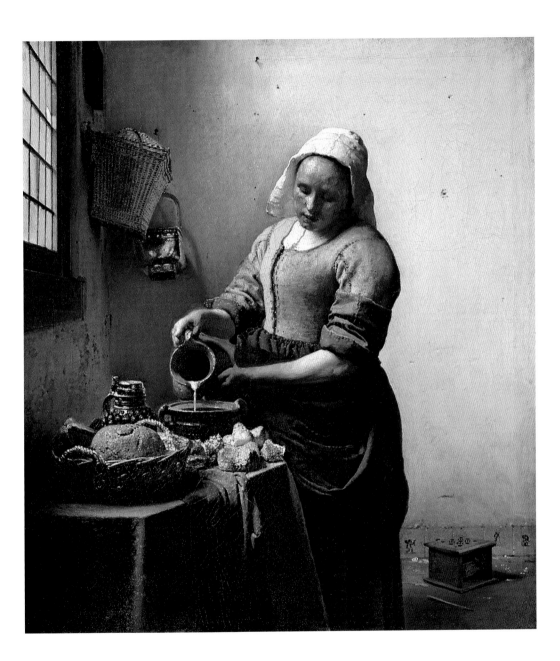

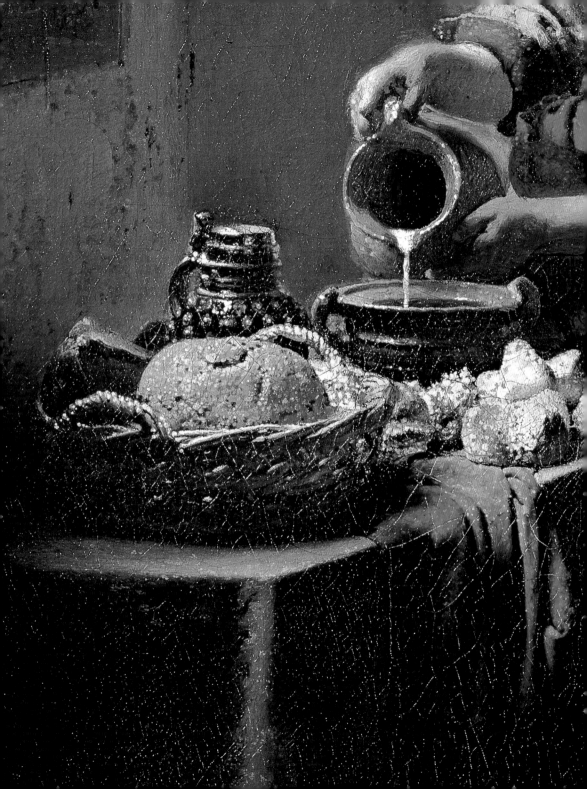

The Glass of Wine

1659–1660

Oil on canvas, 66.3 x 76.5 cm
Gemäldegalerie, Berlin

The painting is documented as of 1736, when it was sold at Jan van Loo's auction in Delft.
Acquired by John Hope in Amsterdam in 1774, it remained in the family until 1898, when the
entire collection was sold by the art dealers P. and D. Colnaghi and A. Wertheimer; it entered
the Gemäldegalerie in Berlin in 1901.

The elegant interior shows a gentleman poised to refill a young lady's glass. A musical
instrument nearby on a chair suggests that they may have played, or be about to play, some
music. It is a typical "merry company" scene built around the consumption of wine and
therefore around love, a genre with which Vermeer had already experimented and which
enjoyed great currency in the Netherlands at the time. However, comparison with Gerard
ter Borch's *A Gentleman Pressing a Lady to Drink* (c. 1660, Royal Collections, Britain) or
Frans van Mieris's *Teasing the Pet* (1660, Mauritshuis, The Hague) reveals just how different
Vermeer's work was, hinting at psychological relationships between the figures and
highlighting states of mind and emotions. Vermeer's great technical skill in rendering light,
fabrics, and furnishings enables the work to be dated to around 1660. The large room in
which the sedate seduction is taking place is perspectively perfect, with a checkered floor,
a table, a lopsided chair holding a cittern, and the cushion on which it rests. The light filters
in from two windows on the left. The larger leaded window contains stained glass, including
a coat of arms, possibly that of Jannetie J. Vogel, the wife of one of Vermeer's neighbors,
and a female figure, probably a personification of Temperance. The scene is, therefore, also
moralistic in tone, a call for moderation, probably reinforced by the painting of the wooded
landscape, by an unknown hand, on the back wall.

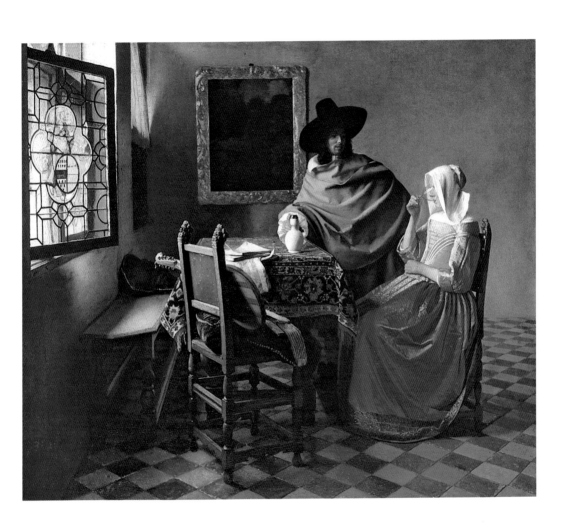

The Girl with Two Men

1659–1660

Oil on canvas, 77.5 x 66.7 cm
Herzog Anton Ulrich Museum, Braunschweig (Brunswick)
Signed on the window pane: "IV Meer"

The painting has been identified as the one sold as a work by Vermeer at the Amsterdam auction of 16 May 1696. The catalogue entry (No. 9) reads: "A gay company in a room, vigorous and good, by the same [Vermeer], 73.0 guilders." It was later cited in a catalogue of the collection of Anton Ulrich, Duke of Brunswick, in 1710, 1744, and 1776. The picture then went to Paris as war booty, at the time of Napoleon I, remaining there until 1815, when it was returned to Brunswick.

Vermeer has painted a typical seduction scene in an orderly interior, with a dejected, possibly jealous, man at the back of the room, his head resting on his hand, and another man paying court to a young woman, offering her a glass of wine and bending over her hand. The girl is wearing a sumptuous red silk dress and smiles at the viewer, acquiescing both to the glass and the courtship. Her amused expression could signify that she is playing the coquette, as Thoré-Bürger described her in the nineteenth century, but also, more prosaically, that she is tipsy. The moralistic tone of the painting is provided by the leaded window, which contains a stained-glass picture of the figure of Temperance next to a coat of arms, a moral note that is in complete contrast to the behavior of the protagonists. This sort of moralizing scene, treated in a more complex manner than the previous ones, was typical of many artists active in Delft at the time, including Pieter de Hooch, who painted *A Woman Drinking with Two Gentleme*n (1658, Louvre, Paris), which is very similar in composition, with all the action taking place in a corner of the room. However, while de Hooch's animated picture, containing four figures, puts the emphasis on the architectural qualities of the room, Vermeer focuses on the group of people, setting them in the foreground. A stern portrait of a man, possibly a forebear, hangs on the wall, while a sober still life comprising a Delft platter with oranges, a white jug, and a white cloth illustrates Vermeer's extremely fine technique, alternating thin layers of paint and *pointillage* in a glistening, light-filled chromatic impasto.

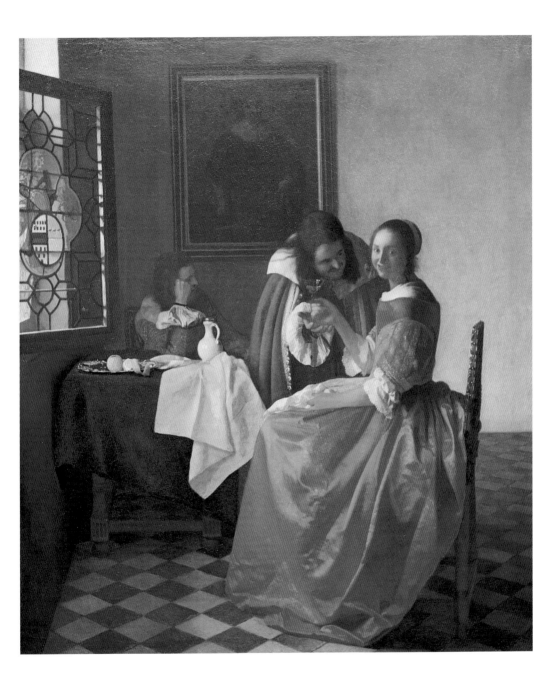

Girl Interrupted at her Music

c. 1660

Oil on canvas, 39.3 x 44.4 cm
Frick Collection, New York

Despite being in such a degraded and poor condition that it could be mistaken for a copy of a Vermeer, the painting would appear to belong to the slender corpus of autograph paintings, sharing the same characteristics of technique, subject, and iconography. Item No. 10 in the catalogue of paintings sold at auction in Amsterdam on 16 May 1696 ("A gentleman and a young lady making music in a room, by the same [Vermeer]; 81.0 guilders") could well have been this painting, but it has been positively identified as a work listed as No. 57 in an Amsterdam auction of 1810; the catalogue described the gentleman as a "music master." Sold for 640 guilders, it passed through various galleries until 1901, when it was acquired by Henry Clay Frick.

In an interior that strongly resembles previous ones in Vermeer, a young woman is sitting holding a music score while a gentleman leans in towards her. The girl has turned to look towards the viewer, rendering the painting more enigmatic still, for the implication of this is not clear. Is it a music lesson, a tryst, or an interrupted recital or concert, as the title suggests? The musical theme, underscored by the shaft of light playing on the musical instrument and scores, is certainly dominant. The love theme is also a powerful one, with a painting of Cupid on the wall, and wine as represented by the carafe and glass. The God of Love is holding a playing card, an allusion to the need for faithfulness in love.

The man is wearing a cloak and may be a suitor, but his feelings are not reciprocated by the girl. He might also be a "music master" who has gone a step too far. Who knows? The birdcage on the wall is a spurious element, a later addition. The painting may have been executed around 1660.

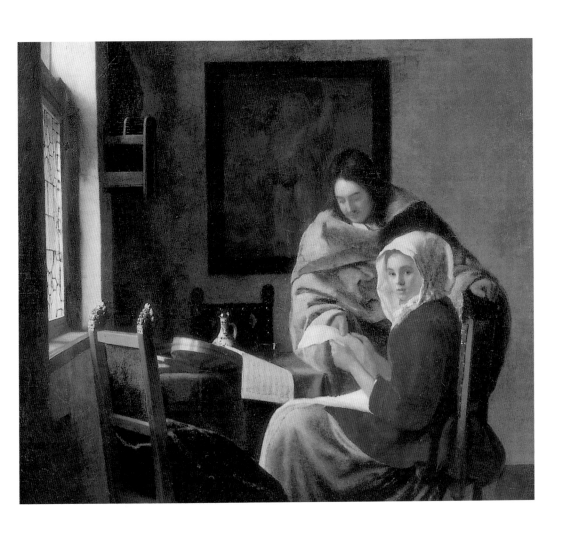

View of Delft

1660–1661

Oil on canvas 96.5 x 115.7 cm
Mauritshuis, The Hague
Signed bottom left, on the boat: "IV M"

"The Town of Delft in perspective, to be seen from the south by J. Van der Meer of Delft; 200.0 guilders" fetched the highest price of all in the Amsterdam auction of 16 May 1696. The painting was acquired by Willem I, first king of the Netherlands, for the royal collections at the Mauritshuis in 1822, in Amsterdam.

This wide-ranging view of his native city is widely considered one of Vermeer's masterpieces. Much admired by Marcel Proust, the painting was the springboard for the rediscovery of Vermeer, even by the general public, and is an extremely fine testament to his poetical and stylistic prowess. It is not an exact, objective view, given that not all of the buildings correspond to the built architecture seen from a vantage point beyond the walls and canals surrounding the historic center of Delft. The city walls and Schiedam Gate with its clock, Rotterdam Gate with its twin towers, and the bell-tower of the Nieuwe Kerk in the center are all recognizable; but Vermeer allowed himself a certain amount of poetic license, adroitly altering reality. He was not overly concerned with achieving an accurate, recognizable reproduction of the view, as, for instance in Jan van der Heyden's topographical _New Town Hall in Amsterdam_, bought by Cosimo II Medici in 1668 and now in the Uffizi. Vermeer's painting treated the city as a place where people live and meet. The combination of light and colors is unusually fine, as is the perspectival distribution of the line of buildings, the cloudy sky above them, and the reflection of the brick walls in the canal. Vermeer actually mixed grains of sand into the paint he used for the tiles, stones, and bricks in order to vary the texture.

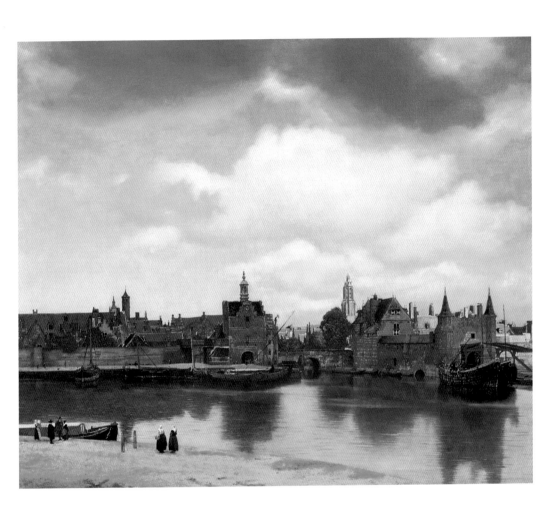

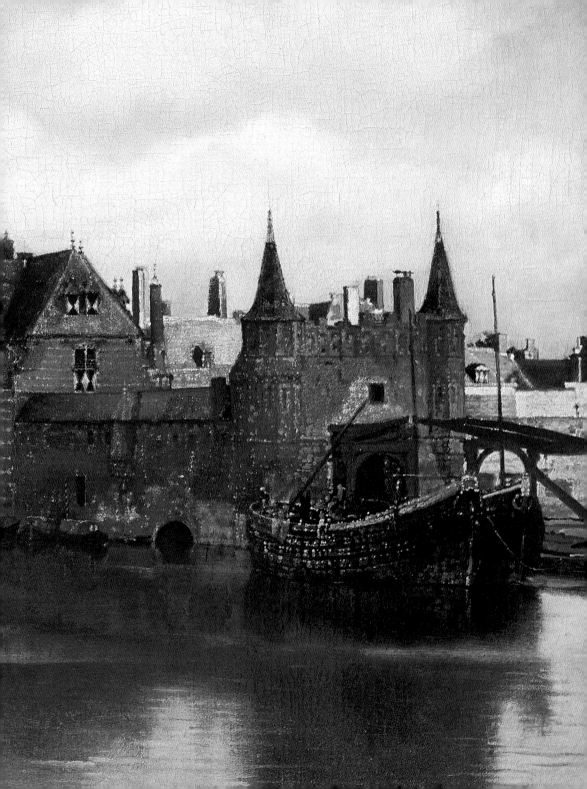

View of Delft (details)

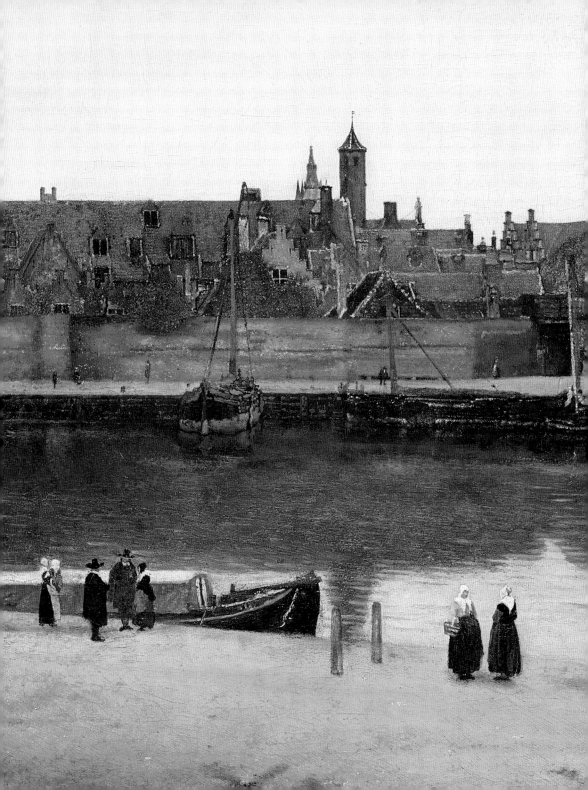

A Lady at the Virginals with a Gentleman (The Music Lesson)

c. 1662

Oil on canvas, 74 x 64.5 cm
The Royal Collection, Windsor Castle
Signed in the lower margin of the frame: "IV Meer"

The painting of "A young lady playing the virginals in a room, with a listening gentleman, by the same [Vermeer]; 80.0 guilders" was sold at the Amsterdam auction of 16 May 1696 (item No. 6), and subsequently acquired in 1718 by the Italian painter Gianantonio Pellegrini, who was in the Netherlands at the time. It later passed into the collection of the English Consul in Venice, Joseph Smith, and thence to the collection of King George II in 1762 as a "Frans van Mieris."

The painting is unquestionably by Vermeer and deals with the common theme of music and love. In a large room with a magnificent checkered floor, a young lady is playing the virginals, while a man stands and listens. The man's intent, rather formal stance suggests that he may be a music master, though he could also be a suitor. This latter hypothesis is underpinned by the presence of the viol, an instrument that, according to the iconography of the time, echoed the sound of the virginals, suggesting the reciprocal feelings of two people in love. The young woman's face, which is clearly turned towards the gentleman, is reflected in a mirror on the wall, as is the painter's easel. Light floods in through two finely leaded windows, highlighting every single object, from the viol on the floor and the table in the foreground, with the familiar thick Oriental rug and the white pitcher, to the magnificent virginals. The instrument is decorated with seahorses and may well be a depiction of one built by the Antwerp specialist craftsman Andreas Ruckers. A representation of *Roman Charity* on the right of the back wall was probably one of the paintings in his mother-in-law's house. Vermeer is here employing musical harmony to express inner emotions, either expressed or unexpressed: this could be the significance of the "picture within a picture." The atmosphere is both tense and intense, bestowing a fascinating air of ambiguity, entirely different from that of Frans van Mieris's rowdy *Duet* (c. 1658, Staatliches Museum, Schwerin), a scene that has been stripped of all mystery.

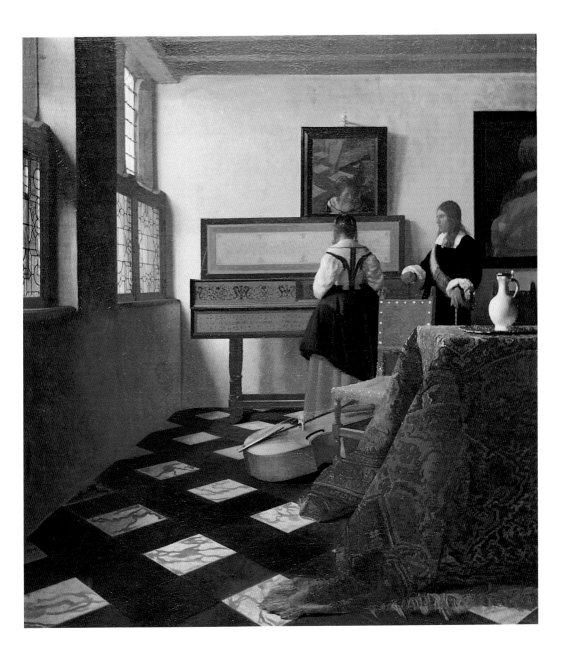

Woman in Blue Reading a Letter

c. 1663

Oil on canvas, 46.6 x 39.1 cm
Rijksmuseum, Amsterdam

This may well be the painting listed as item No. 22 in the Pieter van der Lip Amsterdam auction of 1712. It was much admired during the eighteenth century and passed through several private collections before being acquired by the banker Adriaan van der Hoop in 1839; he then left it, with the remainder of his collection, to the city of Amsterdam. Exhibited at the Rijksmuseum in 1885, it could well be a perfect pendant to *The Milkmaid*, also in the Rijksmuseum, which, despite the differing chronology, has the same statuesque figure, perspectival approach, and vibrant female beauty. A troubled, evocative silence also hangs over this room, which contains a clearly pregnant woman reading a letter, and absence becomes an almost palpable presence, conveyed by the sheet of paper, the empty chair, and the map, all of which allude to an absent person. It is interesting to note that the map of the provinces of Holland and West Friesland, drawn by Balthasar Florisz. van Berckenrode in 1620 and published by Willem Jansz. Blaeu a few years later, is identical to the one in Vermeer's *Officer and Laughing Girl*.

Light streams into the room through an unseen window on the left, leaving part of the foreground in the shade and flooding the rest of the room. The woman, dressed in a blue jacket, has placed a book and a pearl necklace on the table in order to read the letter, which is perhaps from a loved one. The device of the letter was employed by many Dutch artists, such as Gerard ter Borch, whose *Peasant Girl Reflecting on a Letter* (c. 1650, Rijksmuseum, Amsterdam) is on much the same theme, yet lacks Vermeer's meticulous technique and refined sensitivity. Vermeer achieved a perfect balance between the room and the emotional content thanks to his handling of the spatial relationships between the figure, the furnishings and objects, the perspective, and the play of light and color.

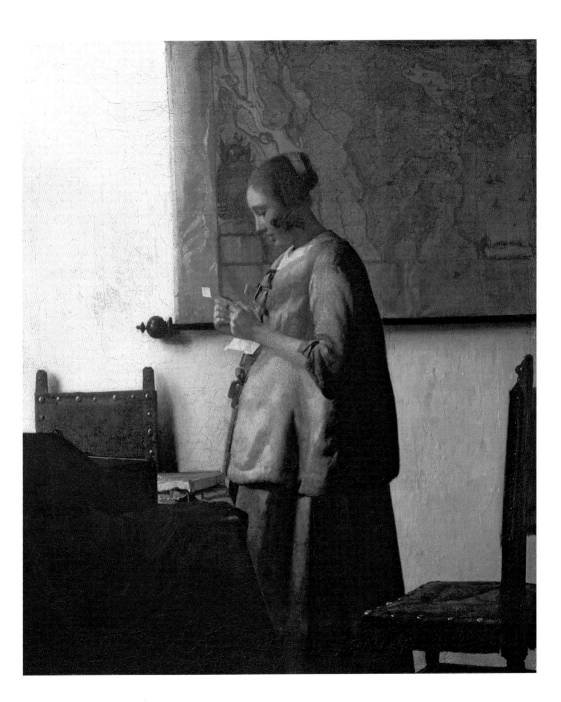

Woman in Blue Reading a Letter (details)

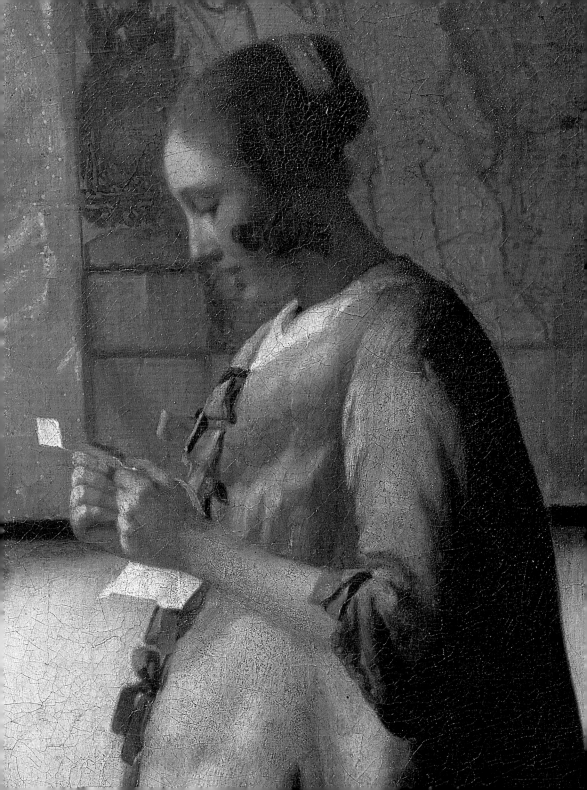

Woman Holding a Balance

c. 1664

Oil on canvas, 40.3 x 35.6 cm
National Gallery of Art, Washington

Sold at the Amsterdam auction of 16 May 1696 as item No. 1 ("A young lady weighing gold, in a box, by J. van der Meer of Delft, extraordinarily artful and vigorous; 155.0 guilders"), the painting was acquired by the buyer who also acquired *The Milkmaid*. After several changes of ownership, it arrived in America in 1911, where its final owner donated it to the National Gallery in Washington.

Arthur K. Wheelock, Jr., maintains that the traditional title of the work, *Woman Weighing Pearls*, was incorrect: the scales are perfectly, gently yet precisely, balanced, but appear to contain nothing at all. It is hard to tell whether the shallow pans do or do not contain any gold, possibly confuting the traditional title, which would therefore read: "A young woman weighting gold [contained] in a box." It was a common subject and one that had inspired painters such as Gabriel Metsu (1654, *The Gold Weigher*, private collection) and Pieter de Hooch (c. 1664, *Woman Weighing Gold*, Gemäldegalerie, Berlin). Strings of pearls are liberally scattered on the table, a precious cascade that follows the direction of the light. The young lady, wearing an elegant dark jacket edged with pale fur, appears to be in the latter stages of pregnancy. André Malraux surmised that this figure, who bears a close resemblance to other women in Vermeer's paintings, was in fact the artist's wife. He may well have been right, since Catharina was often pregnant and the atmosphere is redolent of a tranquil domestic interior, possibly a bedroom. The woman is standing in front of a representation of the *Last Judgment*. The figure of the Archangel Michael often appears in the center of Flemish paintings of the Last Judgment, which accounts for the subtle link between the scene portrayed by Vermeer and the "counter melody" of the paintings on the walls. However, whatever profound secular or religious meaning Vermeer or his contemporaries invested in that small pair of scales is now lost to us, though there has been no shortage of hypotheses.

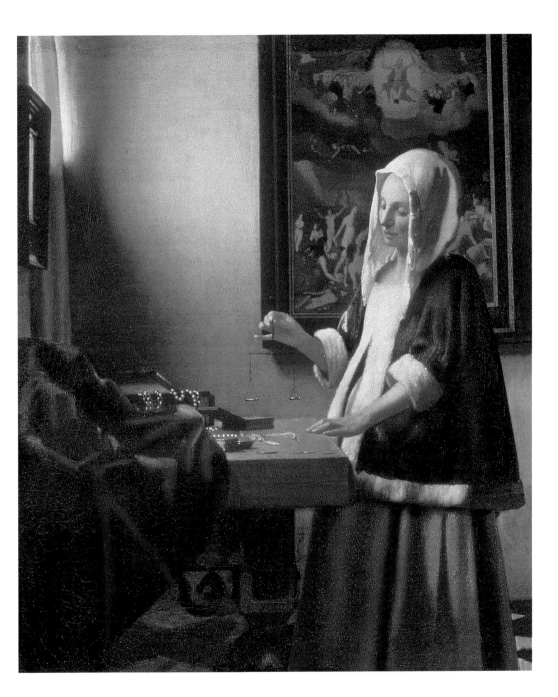

Woman with a Lute

c. 1664

Oil on canvas, 51.4 x 45.7 cm
Metropolitan Museum of Art, New York
Indistinct traces of the signature "Meer" on the wall, below the tablecloth

Sold at the 1817 Amsterdam auction as "Vermeer van Delft" for 65 guilders, the painting was acquired in England by Collis B. Huntington, who bequeathed his New York collection to the Metropolitan Museum in 1897. Like *Girl Interrupted at her Music*, the painting is in a sorry state, with abrasions that detract from Vermeer's chromatic nuances and his subtle use of chiaroscuro. The date of the painting has been the subject of much debate and fluctuates between his early and his later years; the latter seems more likely. The composition of the shadowy foreground is, in fact, very similar to that in the *Woman Holding a Balance* and the *Woman with a Pearl Necklace*, both datable to around 1664 and executed with the aid of a camera obscura.

The subject is typical of Vermeer, as evinced by the list of paintings sold at the 1696 Amsterdam auction. In a corner of a room lit from the left, a young woman wearing a fine pair of earrings and a pearl necklace is playing the lute, caught in the act of trying out a chord. Her absorbed expression and steady gaze are evidence of Vermeer's great sensitivity and skill in capturing women's states of mind.

The woman is wearing the same fur-trimmed yellow jacket as the figure in *Woman with a Pearl Necklace*. The large map of Europe behind her has been identified as one published by Jodocus Hondius in 1613 and republished by Willem Jansz. Blaeu in 1659. The spatial depth appears to have been achieved with the aid of an optical instrument, possibly Galileo's telescope, which, when inverted, would have been useful for emphasizing the foreground and positioning the protagonist at the rear of the painting.

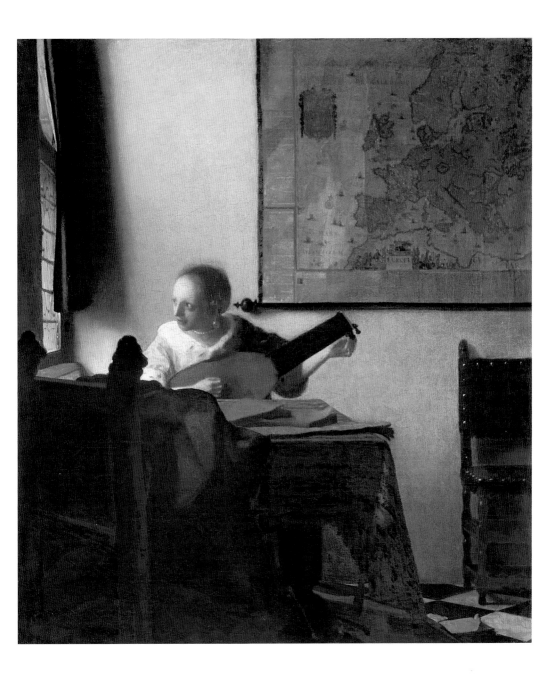

Woman with a Pearl Necklace

c. 1664

Oil on canvas, 51.2 x 45.1 cm
Gemäldegalerie, Berlin
Signed on the tabletop: "IV Meer"

This is one of Vermeer's most fascinating and intriguing paintings, listed as No. 36 in the Amsterdam auction of 16 May 1696 ("A young lady adorning herself, very beautiful, by the same [Vermeer]; 30.0 guilders"). It passed through various auctions and collections, including that of Thoré-Bürger, before being acquired by the Gemäldegalerie in Berlin in 1874. It represents a young woman gazing at herself in a mirror affixed to the wall in the corner of a room containing some elegant embroidered chairs. A shaft of sunlight filters through a window, illuminating the young woman, who is wearing a yellow ermine-trimmed satin jacket, the same garment worn by the figure in *Woman with a Lute*. She is observing her own face, framed by bows and earrings, while holding the two small yellow ribbons at either end of a string of pearls. The delicate, faintly smiling profile reveals her pleasure at what she sees. Her fresh, optimistic expression is quite different from that of the stern, tired milkmaids and housemaids in Vermeer's paintings. He has captured the young woman's fascinated delight perfectly. The motif was a common one in Dutch seventeenth-century painting, as demonstrated by the *Young Woman before a Mirror* by Frans van Mieris (c. 1662, Gemäldegalerie, Berlin), for example. Critics have attempted to probe the deeper meaning of Vermeer's picture, suggesting that it may derive from the ancient theme of Vanitas, the transience of things, or, alternatively, that the young woman is a symbol of purity, reflected in the mirror. X-ray analysis has shown up the earlier presence of a map and a lute, subsequently removed by the artist himself. However, the riddle of the picture's significance remains, as was possibly the artist's intention.

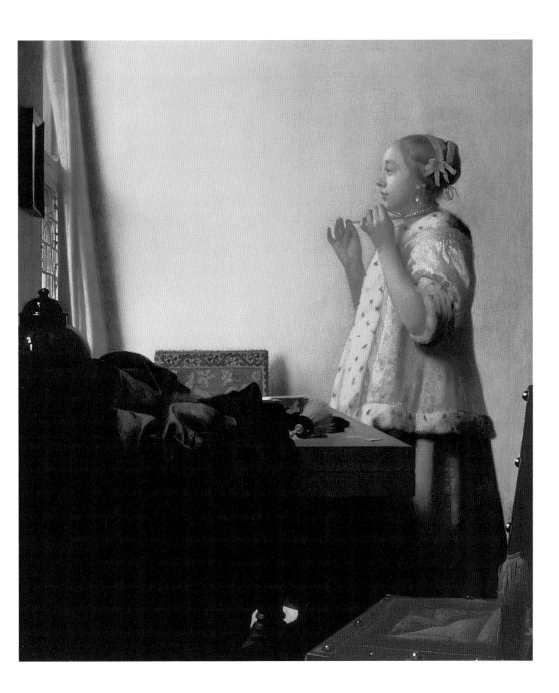

Young Woman with a Water Pitcher

1664–1665

Oil on canvas, 45.7 x 40.6 cm
Metropolitan Museum of Art, New York

After passing through several different collections, this painting, which had been attributed to both Gabriel Metsu and Pieter de Hooch, was donated by its final owner to the Metropolitan Museum in New York in 1888.

Undoubtedly by Vermeer, under whose name it was exhibited in 1878 at the Royal Academy in London, the painting shows a woman standing in the corner of a room, turned towards her right, opening a window with her right hand while holding a brass water pitcher with her left. The pitcher rests on a ewer made of the same metal, which, along with a small box, sits on a table covered with a thick rug. A map of the Seventeen Provinces hangs on the wall behind her. Vermeer has portrayed a simple, feminine gesture; the young woman may well be a faithful, well-dressed maid, her head and shoulders covered by her spotless white headscarf, possibly caught while preparing the morning toilette for an unseen mistress. On the other hand, she might be about to water some hypothetical flowers on the window-sill for the mistress of the house. There is so much to be pondered about this superb painting, which captures a specific moment in everyday life in the seventeenth-century and yet is also timeless. The extremely refined colors are shades of yellow and blue. The soft, gentle light illuminates every single detail, from the tired plaster on the walls to the woman's skirt, crafted with gentle dabs of the paintbrush in order better to render the woolen fabric, and the shiny pitcher and ewer. The date of the picture is still a matter for debate, but it would appear to belong to Vermeer's later period, around the mid 1660s. Although some of the iconographical elements, such as the rug on the table and the woman's dress, might point to his early period, a certain sparseness in the figure and the broad treatment of light and color make it more likely to have been executed in 1664–1665, when he made a series of paintings of single female figures.

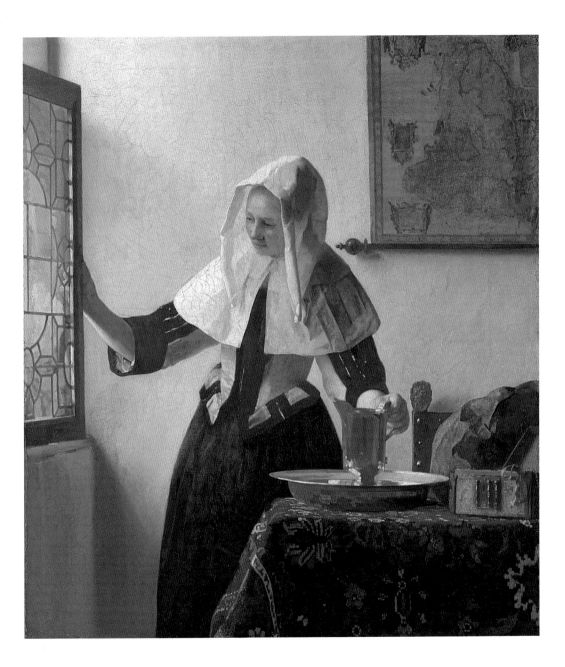

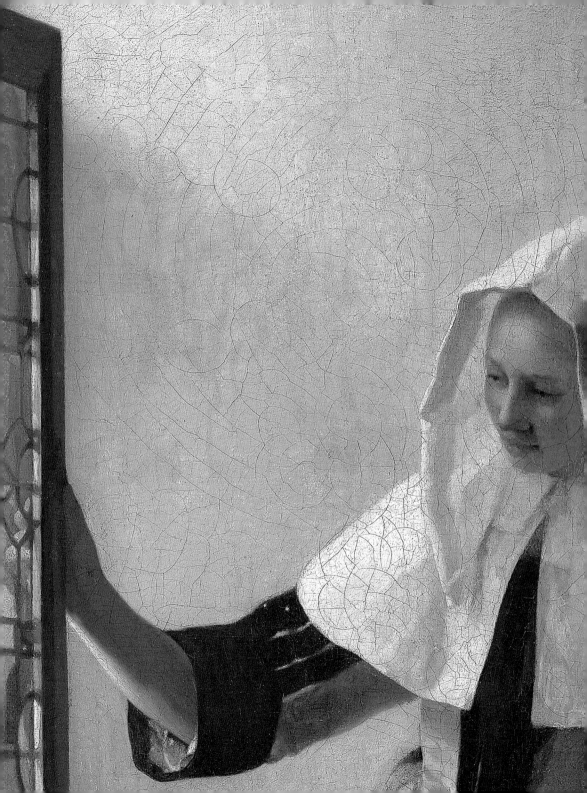

A Lady Writing

c. 1665

Oil on canvas, 45 x 39.9 cm
National Gallery of Art, Washington

The painting is described in the catalogue for the Amsterdam auction of 16 May 1696 as "A young lady writing, very good, by the same [Vermeer]; 63.0 guilders." It passed through several collections before being donated to the National Gallery in Washington by the Havemeyer family in 1962.

This is another late masterpiece. Writing at a table, a young woman with a fashionable chignon stops for a moment to look up and out at the viewer; she has a goose quill in her right hand and is using her left hand to steady a sheet of paper. She is wearing the famous yellow ermine-trimmed satin jacket seen on so many of his female figures, a garment that belonged, as we know from the inventory of her effects, to his wife Catharina. This, together with the very careful crafting of the face, leads us to suppose that the woman must indeed be his wife, a supposition supported by the intimate atmosphere: a darkened room with a large picture of a still life of musical instruments on the wall, and a table on which lie a pearl necklace, a jewelry box, an inkwell, and a yellow ribbon of the kind she is wearing in her hair. It is not hard to imagine Vermeer painting his wife for posterity, lit up in a corner of the bedroom or in the usual, carefully darkened studio. The atmosphere is warm and silent, that of a tranquil evening just before bed. He tackled this particular subject on two other occasions (*Mistress and Maid* and *Lady Writing a Letter with her Maid*), the theme of love being a common Dutch tradition. Around 1655, Gerard ter Borch, for example, painted *Woman Writing a Letter* (Mauritshuis, The Hague), in which the woman is seen sitting in front of a canopied bed, thereby stressing the amorous nature of the missive. In Vermeer's version , the letter itself takes second place, the emphasis being on the intriguing smile of the female figure: At whom is she looking? Could it be the artist himself?

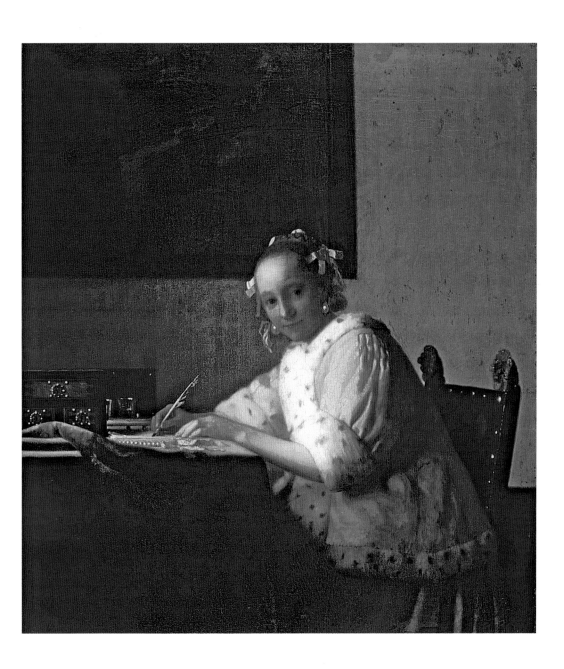

Girl with a Pearl Earring

c. 1665

Oil on canvas, 44.5 x 39 cm
Mauritshuis, The Hague
Signed top left: "IV Meer"

Documents show that Vermeer painted several portrait "heads" or *tronien*, as they were known. They were a very popular genre, featuring in costume portraits and historical scenes. This girl, with her turban and pearl earring, probably conforms to this genre, although it has not been possible to identify the painting positively as one of the two "*tronien* painted in the Turkish manner" listed in the inventory of the Vermeer family assets drawn up in 1676, or as one of the three itemized pictures (as Nos. 38, 39, and 40) in the catalogue for the 1696 Amsterdam auction. There is a record of the painting in 1881, when it was bought for a derisory sum; it then passed through several different collections before being bequeathed to the Mauritshaus in 1903.

It is one of Vermeer's best-known works, famous enough to have been dubbed "Vermeer's Mona Lisa." It also provided the inspiration for a novel and film. The girl's face, shown in three-quarter view and suffused with light, is unusually beautiful: her gently parted lips, her large eyes, and her slender, straight nose are immediately striking. The dark background, a new departure for Vermeer, has the effect of making the ochre jacket, the yellow and blue turban, and the superbly painted pearl earring stand out. His use of *velatura* enabled him to make the skin look velvety, and he used minuscule pink dots to accentuate the contours of the mouth. It is not easy to identify the allegorical character to which the girl might correspond because, like all Vermeer's paintings, she seems timeless, forever contemporary. The closest description could indeed be a "*tronien* in the Turkish manner," as per the 1676 inventory. Of all the responses to the painting, the most curious and poetic observation could well be that of the Dutch poet and critic Jan Veth, who in 1908 wrote: "More than with any other Vermeer, one could say that it looks as if it were blended from the dust of crushed pearls."

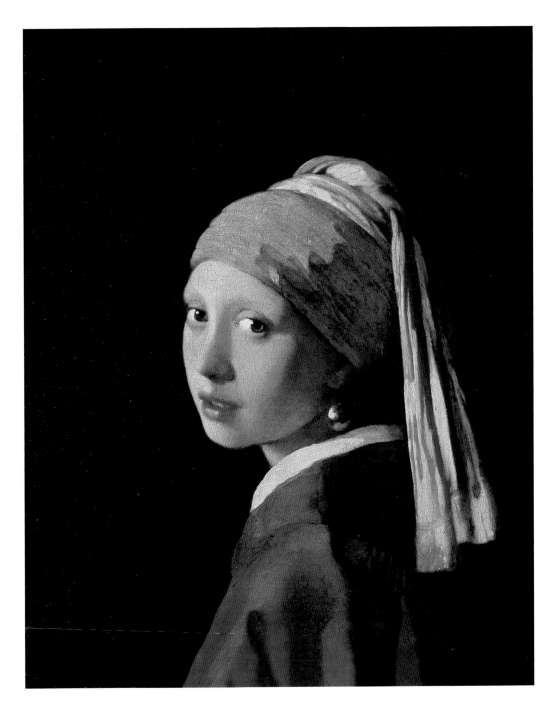

Girl with a Red Hat

c. 1665

Oil on panel, 22.8 x 18 cm
National Gallery of Art, Washington
Signed top left: "IVM"

The painting surfaced for the first time on 10 December 1822, at the auction of the Lafon-
taine collection in Paris, under the name of "Vermeer van Delft," where it sold for 200 francs.
It then entered the collection of Baron Atthalin in Colmar, subsequently appearing at the
Knodler & Co. art gallery in New York, where it was bought by Andrew W. Mellon, who made
it over to the National Gallery of Art in Washington in 1937. Several scholars (Blankert, 1981;
Larsen, 1996; Arasse, 2006; and others) have expressed their doubts over the painting's
authenticity, though others consider it to be one of Vermeer's finest works.
It is in fact a pastiche, executed at a later date, which could not have been made by Vermeer
for various reasons: it is painted on wood, rather than on canvas like all his other authentic
works, and it has the feel of a "snapshot," which is at odds with his style. Furthermore,
X-rays have shown that the painting was executed on top of a portrait of a man in the style
of Rembrandt and that the pre-nineteenth-century pigments derive from that earlier
painting. The rendering of the tapestry in the background is coarse, and even the signature
is dubious.
The position of the figure is also incongruous, particularly in relation to the lion's head
finials on the chair, which are the wrong way round, something that would never happen in
Vermeer. Various critics have tried to justify the painting as part of Vermeer's oeuvre,
making much of the fact that the figure could be a *tronie*, or portrait head, "in the ancient
manner" or "in the Turkish manner," but even this does not hold water because there is
nothing remotely Oriental about the girl's get-up. The characteristics of this painting crop
up again in another small oil on panel, *Girl with a Flute*, also in the National Gallery in
Washington, which is no longer attributed to Vermeer, but thought to be a nineteenth-
century fake. It is worth bearing in mind the fact that in Paris during the nineteenth century
a school of forgers was active producing seventeenth-century Dutch paintings. In this case,
it is what Daniel Arasse described as a "true fake."

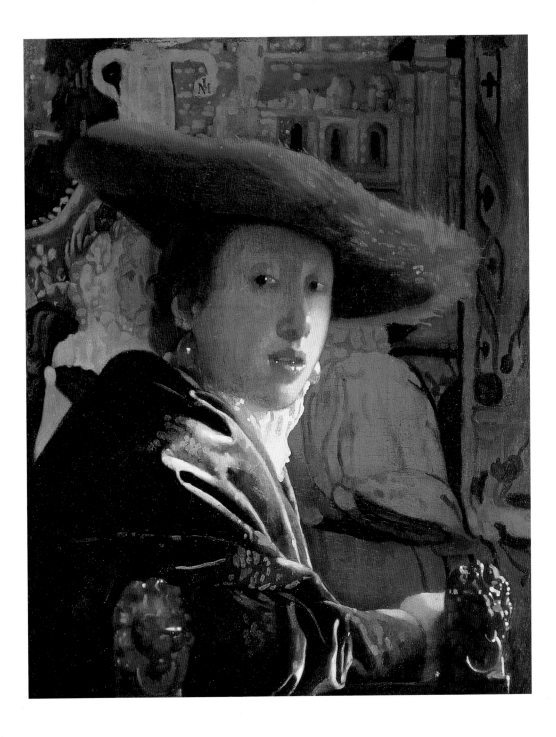

Girl with a Red Hat
(details)

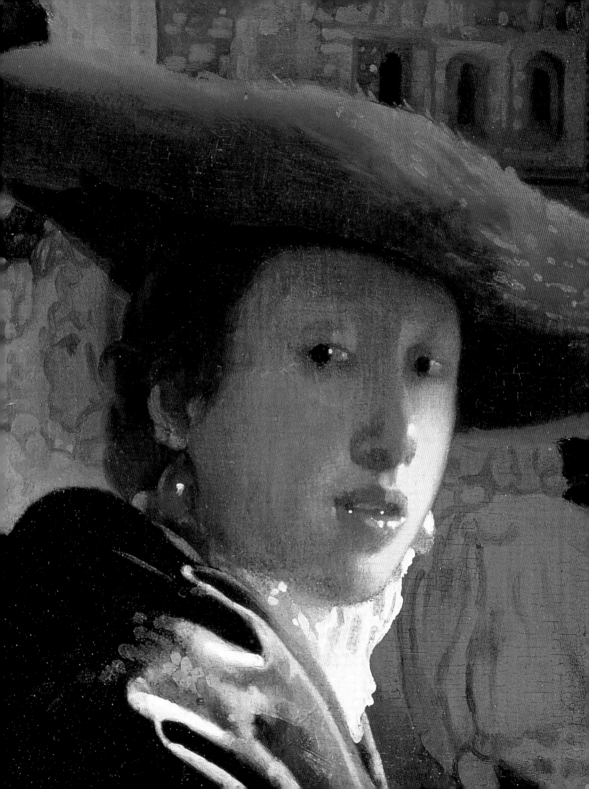

The Concert

c. 1665–1666

Oil on canvas, 692 x 628 cm
Isabella Stewart Gardner Museum, Boston

This painting was described as being by "Jan van der Meer di Delft" in the auction held in Amsterdam in 1780. It then passed through various hands, including Thoré-Bürger's, before being acquired by Isabella Stewart Gardner in 1892.

It is similar to *The Music Lesson* (*A Lady at the Virginals with a Gentleman*), yet more complex and developed. A trio are playing music in a large room with a black-and-white patterned floor. One of the girls is playing the virginals, the other is singing, and a gentleman with his back to us is accompanying them on another musical instrument. They are all engrossed in the music. There are more instruments in the partly shaded, partly sunlit, foreground; several sheets of music and a cittern rest on the table, which is covered with the usual rug, and a viola da gamba lies on the floor. There are two large pictures on the back wall: a wooded landscape in the style of Jacob van Ruisdael, and Dirk van Baburen's *The Procuress*, which also appears in *A Lady Seated at the Virginals*, and which belonged in the Vermeer home, itemized in the inventory of assets drawn up after the painter's death. The device of the picture within a picture has served to underpin the symbolic value of the painting. Some art historians believe that the presence of van Baburen's *The Procuress* could mean that Vermeer's painting is set in a bordello. Nothing seems less likely, given the tranquil, almost chaste atmosphere of the painting, in which music would appear to play a fundamental role. One wonders what significance might therefore be attached to the wooded landscape. If a symbolic value is really to be attributed to *The Concert*, it could lie in the contrast between the air of musical harmony, underscored by the tranquil landscape, and the lasciviousness of the procuress. It may well be the case, however, that Vermeer simply included the two paintings because they happened to be hanging on the walls of the room.

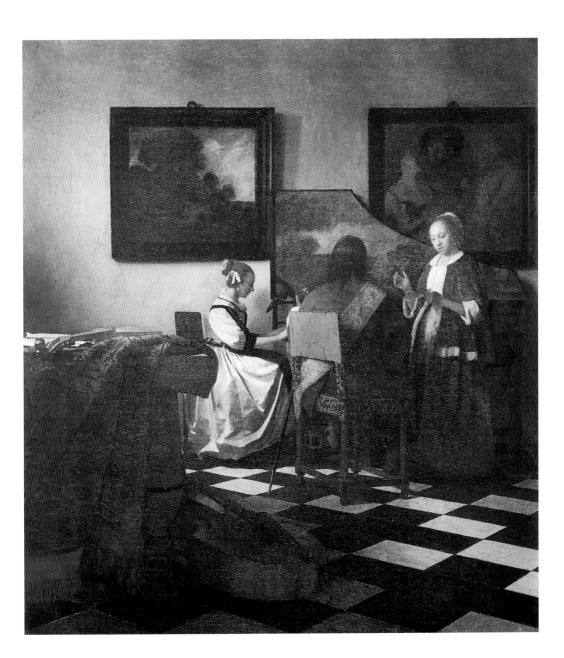

Head of a Young Woman

c. 1666–1667

Oil on canvas, 44.5 x 40 cm
Metropolitan Museum of Art, New York
Signed top left

This may well be one of the "*tronien* in the Turkish manner" listed among the family assets in the 1676 inventory of Vermeer's estate, but there is nothing to confirm this. The first definite mention of the painting goes back to 1829, when it appeared in the collection of Prince Auguste d'Arenberg in Brussels. It was hidden during the First World War and taken to America, where Mr and Mrs Charles Wrightsman donated it to the Metropolitan Museum in New York. It is similar in approach to *Girl with a Pearl Earring*, but the model is not the same. She is less beautiful, although her features are characteristic, with a high, wide forehead reminiscent of that of the sitter in his *Lady Writing a Letter with her Maid*. The young woman stands out against a dark background, as so often in portraits of the time (for example *Portrait of the Artist's Wife* by Frans van Mieris, dated c. 1657–1660, National Gallery, London), but its appeal lies in the light suffusing the young face, the detached expression, and the fine pearl earrings. Her coiffeur, featuring a chignon and headscarf, is not dissimilar to that of the young woman in *Girl with a Pearl Earring*. It is one of Vermeer's later works, probably executed around 1666–1667, after *Lady Writing a Letter with her Maid*. If it is indeed a portrait of one of his daughters, as has been postulated, it could be of his eldest daughter, Maria, who would have been twelve or thirteen at the time. Vermeer was surrounded by women, his wife, his mother-in-law, several daughters and various maids, and loved painting female figures, which he did with great sensitivity.

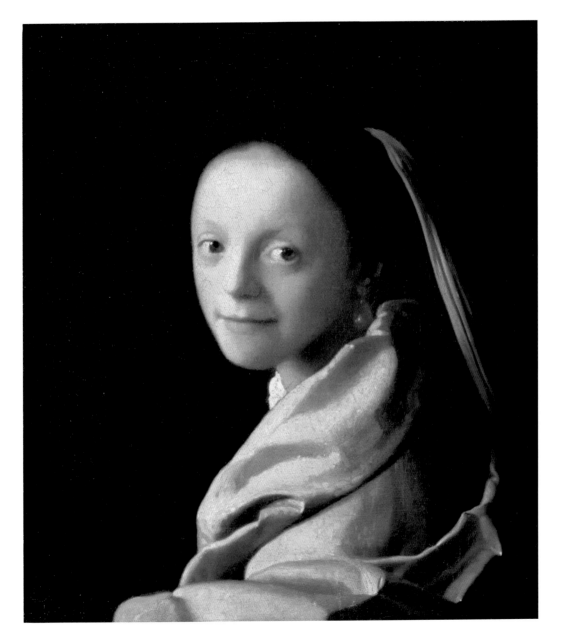

The Art of Painting

c. 1666–1667

Oil on canvas, 120 x 100 cm
Kunsthistorisches Museum, Vienna
Signed on the map to the right of the girl: "I Ver. Meer"

This extraordinary painting was given by Catharina Bolnes, Vermeer's widow, to her mother on 24 February 1676, in part payment for various loans, possibly with the intention of with-holding it from a forthcoming auction held to pay off creditors. The following year, Maria Thins complained that, despite this transfer of ownership, the bankruptcy trustee had included the work in the announcement of the auction of the family's entire assets. Nothing is known about the painting's fate on that occasion. It is known to have belonged in the collections of Gottfried van Swieten and Count Czernin during the nineteenth century, before becoming the property of Adolf Hitler in 1938; it was acquired by the Kunsthisto-risches Museum in 1946.

The painting, also known as *The Painter and his Muse* and *The Studio*, is a late work. The breadth of the subject and the size of the painting suggest that Vermeer saw this as his claim to fame as an artist, as his artistic statement and legacy. The painter, whose face is not glimpsed—a first for self-portraits and portraits of the time—is seen from behind, sitting at his easel, yet ideally placed for the viewer, in the line of sight of the studio, beyond the heavy curtain. A woman wearing a laurel wreath is posing in the room, looking more like a young model than a classical Muse, gracefully holding a trumpet, representing Fame, in her right hand, and a book, representing History, in the left. There are other items linked to the liberal arts on the sunlit table; a wealth of contemporary symbolism was presented in Cesare Ripa's emblem book *Iconologia*, which was translated into Dutch in 1644.

A sumptuous heavy curtain is drawn back to reveal an elegant room that could pass for a stage set, emphasizing the furnishings in the studio, the fine marble floor, and an elegant chandelier worthy of Jan van Eyck. A big map of the Netherlands hangs on the back wall, showing the Seventeen Provinces before the split of 1581. Historians have come up with various complex interpretations for the painting in an attempt to unpick its subtle meaning, which still remains deeply fascinating.

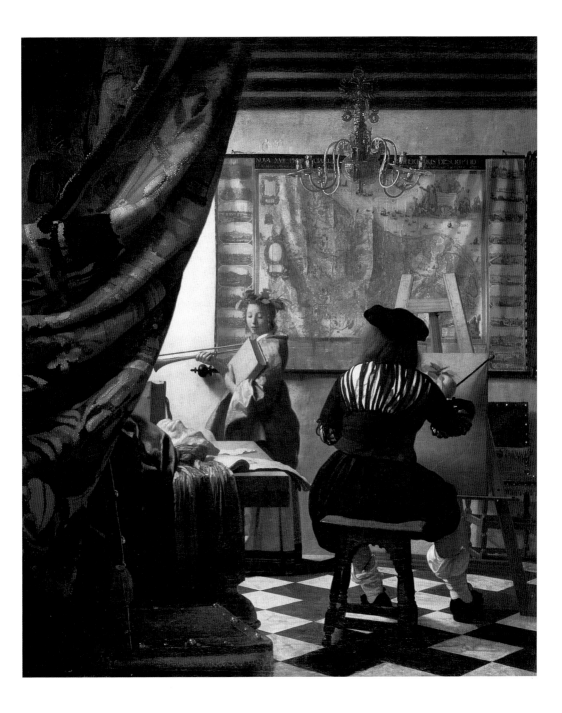

The Art of Painting
(details)

Mistress and Maid

c. 1667

Oil on canvas, 90.2 x 78.7 cm
Frick Collection, New York

This is undoubtedly item No. 7 in the catalogue for the Amsterdam auction of 16 May 1696, a painting described as "A young lady who is being brought a letter by a maid, by the same [Vermeer]; Price 70.0 guilders." It is less likely that the description refers to *The Love Letter* in the Rijskmuseum in Amsterdam, in which the missive appears already to have been delivered. After passing through various European collections, the painting was acquired by the Frick in 1919.

A maid is holding out a letter to her mistress who, surprised, stops writing her letter, puts down her quill and looks up at the maid, raising a hand to her chin. Vermeer has rendered the gestures of the two women very naturally, underscoring the complicit relationship between them. The maid seems well aware of the importance of her missive, delivered in haste, and the woman, who had been concentrating on her writing, appears to be interested in what the maid has to say. The mistress is wearing large pearl earrings and the now familiar yellow satin jacket trimmed with ermine, and her hair is fashionably coiffed, with a braided chignon, ringlets tumbling down over her temples. She is sitting writing at her table, the same one that has appeared in other paintings, covered with a blue cloth on which sits a fine wooden box and some inkwells, which make up a splendid still life. This is a room with which we are well acquainted by now, an intimate space where letters are written and received, possibly the bedroom; Vermeer provides no clues, leaving the background dark and mysterious, like that in the two female portraits of the same period. The still, unreal light filters in from the left, illuminating the two women and subtly highlighting the folds and creases of the fabrics, and the pearls adorning the chignon.

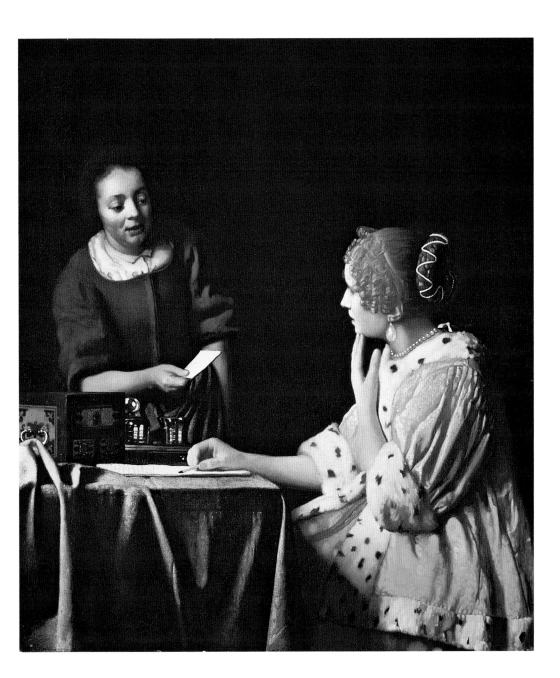

The Astronomer

1668

Oil on canvas, 50 x 45 cm
Musée du Louvre, Paris
Signed and dated on the cupboard: "IV Meer MDCLXVIII"

The Astronomer is closely related to *The Geographer* in the Städelsches Kunstinstitut in
Frankfurt. They are likely to have been commissioned by the same person, certainly a
scientist. The paintings, both documented from the eighteenth century, are almost exactly
the same size and both feature unusual male protagonists; they may well be pendants,
having been in the same collections until 1778, when they were split up, *The Astronomer*
being acquired by the Louvre in 1983.

Vermeer would undoubtedly have had scientist friends with whom he could discuss the use
of optical instruments, such as the camera obscura, in painting, and he has rendered the
interior of the astronomer's room with great precision. The man is shown partly rising from
his chair in order to turn the celestial globe on the table, looking for a particular point. As in
Mistress and Maid, Vermeer has again achieved an extremely natural gesture.

Instruments are dotted around the room: books, an astrolabe, a compass lying on the table,
which is covered with a partly rucked-up rug, this time blue rather than red; the globe is
a faithful reproduction of the one designed by Jodocus Hondius in 1600. On the back wall,
next to the cupboard, there is a painting depicting *The Finding of Moses*, which could resonate
with the astronomer, though the significance of any possible relationship remains obscure,
despite numerous attempts to decipher it. A warm light flooding in from a window on the
left illuminates the scientist, whose young face bears a marked resemblance to that of the
geographer. It is perfectly possible, but by no means certain, that this may have been the
famous scientist Anthonij van Leeuwenhoeck, a specialist in microscopy, who was appointed
trustee of Vermeer's estate. Both signature and date appear dubious, albeit old. The painting
was probably executed in 1668.

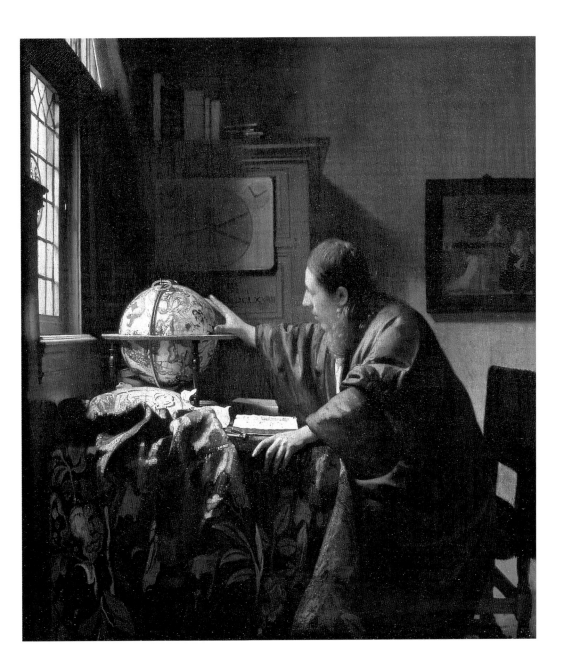

The Geographer

1668–1669

Oil on canvas, 52 x 45.5 cm
Städelsches Kunstinstitut, Frankfurt
Signed on the cupboard: "Meer" and on the wall top right:
"I. Ver Meer MDCLXVIIII"

In an interior that closely resembles the room seen in *The Astronomer*, a young man is seen bending over a table laden with papers and books, holding a pair of dividers in his right hand. He is gazing reflectively at an indeterminate point. The room is a geographer's studio, containing a terrestrial globe (designed by Jodocus Hondius in 1618) on top of the cupboard, books, a nautical map by Willem Jansz. Blaeu (Deutsche Staatsbibliothek, Berlin) on the back wall, and a setsquare on a stool to the right. There are rolls of paper on the floor and the usual magnificent rucked-up rug on the table. The elegantly embroidered chair also appears in *Woman with a Pearl Necklace* and *The Concert*.

Clearly Vermeer has relied on both observation and imagination to reconstruct the studio of a scientist—whom many experts believe to be, like the astronomer, the young scientist Anthonij van Leeuwenhoeck, who had qualified as a topographer in 1669. The theory that a symbolic meaning links the two paintings—that of deep scientific research—is supported by the celestial globe (astronomer) and the terrestrial globe (geographer). In his imagination, the astronomer/geographer is able to travel beyond the confines of his little room to unknown starry or terrestrial universes, conquering them in the name of science. There is no need for physical travel: study, reflection, and analysis are all it takes to harness the ray of light that illuminates new, infinite, possibilities. Perhaps this is actually Vermeer's message; he was, after all, a cultured seventeenth-century intellectual living in the Netherlands, the country with the best schooling in Europe at the time, with a tradition of exploring reality rationally, albeit a reality seen as concealing a multitude of symbolic meanings passed down by long tradition. The signatures on the cupboard and on the wall are both old, but possibly not authentic. Like *The Astronomer*, the painting was probably executed around 1668.

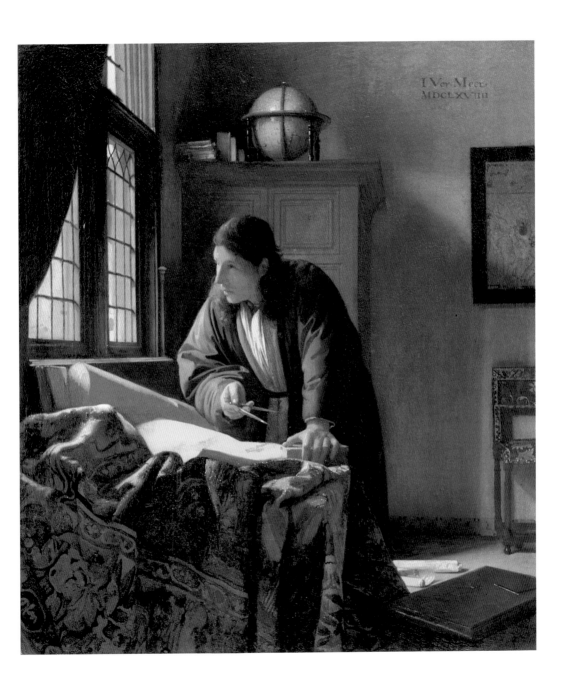

The Lacemaker

1669–1670

Oil on canvas (transferred to panel in 1778)
23.9 x 20.5 cm
Musée du Louvre, Paris
Signed top right: "IV Meer"

This extraordinary painting was listed as item No. 12 in the 1696 Amsterdam auction:
"A young woman doing needlework, by the same [Vermeer]; 28 guilders." After passing
through various private collections, it was acquired by the Louvre in 1870.

It is a small painting, and, unlike Vermeer's other interior scenes, the girl intent on her
lacemaking is represented in the foreground, drawing the viewer's eye towards her, while
the surrounding space consists merely of a neutral background. It may indeed be this
simplicity that makes the painting so fascinating, involving the viewer in the scene. The
subject is not unusual: there are several sixteenth-century precedents and fine contemporary
examples, including versions by Nicolaes Maes (1655, Mansion House, London) and Caspar
Netscher (1662, Wallace Collection, London); the painting also bears comparison with Diego
Velázquez's *The Needlewoman* (1635–1643, National Gallery, Washington). Nonetheless, no
other painting is really comparable to this tranquil, meditative work. A young woman is
concentrating on her lacemaking, bending over a small worktable. She is well coiffed, with
a braided chignon and ringlets on either side of her face, apparently concentrating on the
movement of her hands. Her work tools lie before her: an embroidery cushion, needles,
spools and threads, their outlines crisp and fluid.

The figure of the lacemaker recurs often in Dutch painting as a symbol of industriousness
and domestic virtue: the small parchment-covered volume, possibly a prayer-book, on the
table, serves to confirm the virtuous character of the girl. Vermeer's treatment of the mass
of threads and the young woman's face, lit by a shaft of light from the right, is at its most
sublime.

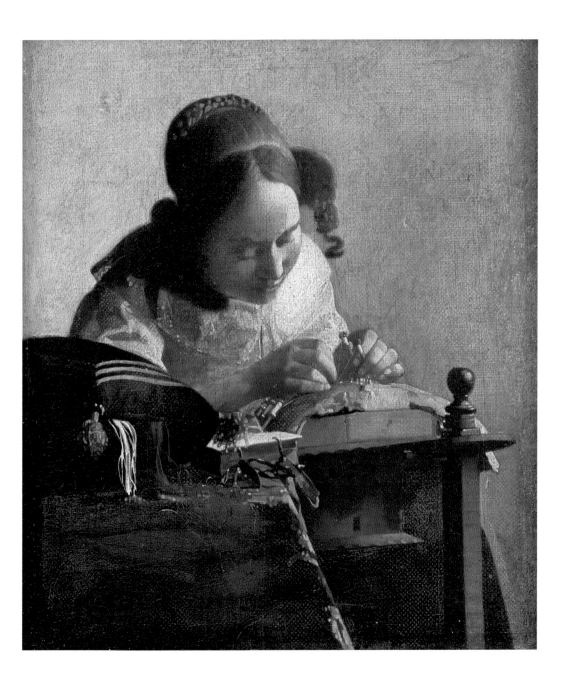

The Lacemaker
(details)

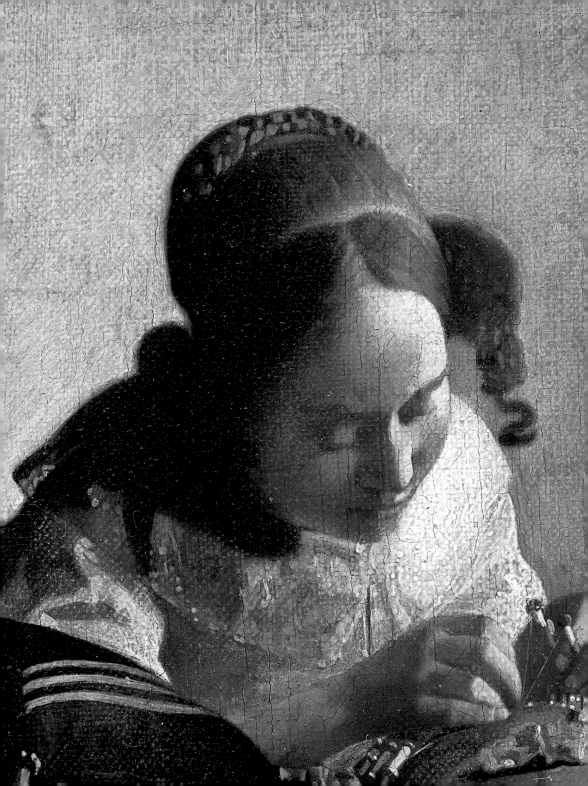

The Love Letter

1669–1670

Oil on canvas, 44 x 38 cm
Rijksmuseum, Amsterdam
Signed on the wall, above the basket: "IV Meer"

The Love Letter appeared on the art market during the late nineteenth century (unless it does, in fact, correspond to item No. 7 in the 1696 Amsterdam auction: "A young lady who is being brought a letter by a maid, by the same [Vermeer]; 70.0 guilders."). It was put up for auction in Amsterdam in 1892 and acquired by the Rembrandt Association, which donated it to the Rijksmuseum the following year.

The canvas is not dated, but the abbreviated version of Vermeer's signature appears on the back wall, to the left of the maid. Stylistically, however, it belongs around 1669–1670. It is in fair condition overall, considering the fact that it was ripped from its frame and stolen in 1971, with the loss of approximately half a centimeter of painted surface along each side.

The painting is a fine example of Vermeer's poetry and creativity, incorporating details and items from other works, such as the tapestry curtain and the mistress's fur-trimmed yellow day jacket, which features in no less than six of his paintings.

With his usual delicate touch, Vermeer has depicted a tranquil domestic scene, illuminated by light coming from the left. He was surrounded by women at home (his wife, mother-in-law, and daughters) and had great insight into the female mind, as so ably demonstrated by this painting. An understanding built on looks, feelings and complicity serves to overcome social barriers. The scene is generally interpreted as representing a woman anxiously holding a love letter she has just been given, the shrewd maid, who probably already knows what was in it, smiling reassuringly. As so often, Vermeer here employs the trope of the "picture within a picture." According to Dutch tradition, the calm sea in the painting behind the two women is an emblem of happy love, while in various images and proverbs, the unfurled sails of the ship are accompanied by the motto: "Even though you are far away, you are never out of my heart." The broom and slippers abandoned in the foreground accentuate the quiet, everyday character of the picture. These objects mark the divide between the darkened antechamber in which the viewer finds himself, and the lighted room in which the scene is set.

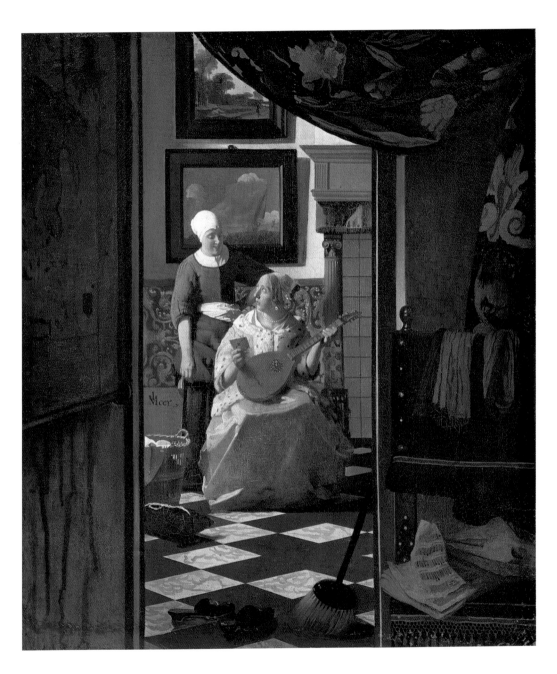

The Love Letter
(details)

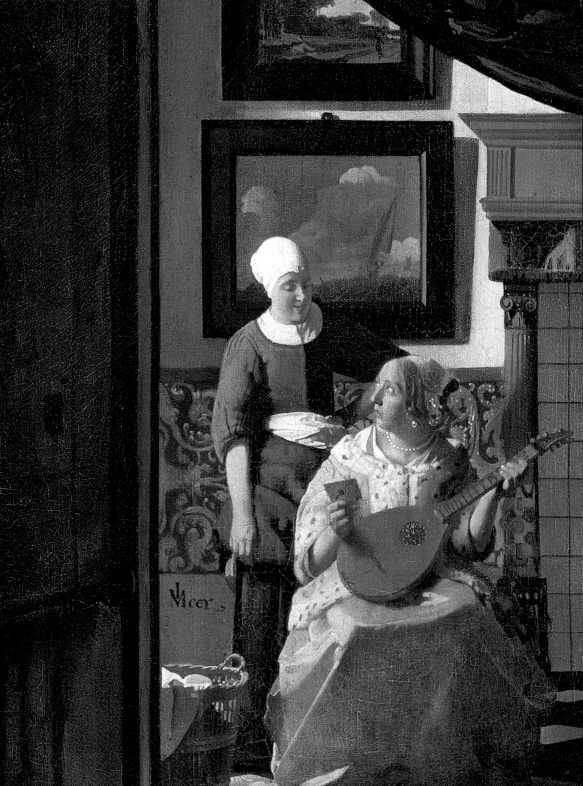

Lady Writing a Letter with her Maid

c. 1671

Oil on canvas, 72.2 x 59.7 cm
National Gallery of Ireland, Dublin
Signed on the piece of paper projecting from the table: "IV Meer"

This is most probably the painting of "two personages, one of whom sits and writes a letter" that was given, along with *The Guitar Player*, to van Buyten, the baker, on 27 January 1676 as security for a debt amounting to 617 guilders. The painting moved between several different private collections over the course of the eighteenth and nineteenth centuries, and was stolen twice by Irish extremists during the twentieth century before being acquired by the National Gallery of Ireland in Dublin.

Vermeer is again tackling the theme of the letter: a young woman wearing a lace cap is sitting at a table writing a letter, while the maid waits, smiling patiently and peeping out of the window. The woman's pose is in complete contrast to that of her placid maid. She is clearly very taken up with her writing and looks as though she may be dashing off a response to an unwelcome letter, possibly the crumpled page on the floor, with a wax seal beside her. The room is spacious and almost stark: the table is covered with a fine rug, the chair with smart blue fabric. A cold, clear light filters through the leaded window, reverberating on the two women and the huge painting *The Finding of Moses* on the wall, the same as the smaller version in *The Astronomer* and presumably a painting in the artist's own collection. The story of Moses, discovered among the bulrushes by the Egyptian Pharaoh's daughter, was frequently interpreted during the seventeenth century as proof of the intervention of Divine Providence. This meaning could also extend to Vermeer's main painting, if a close connection between the two paintings, the real one and the picture within a picture, were being sought: Vermeer may have wished to allude to a possible reconciliation between the woman and the author of the discarded letter. This, however, is pure conjecture.

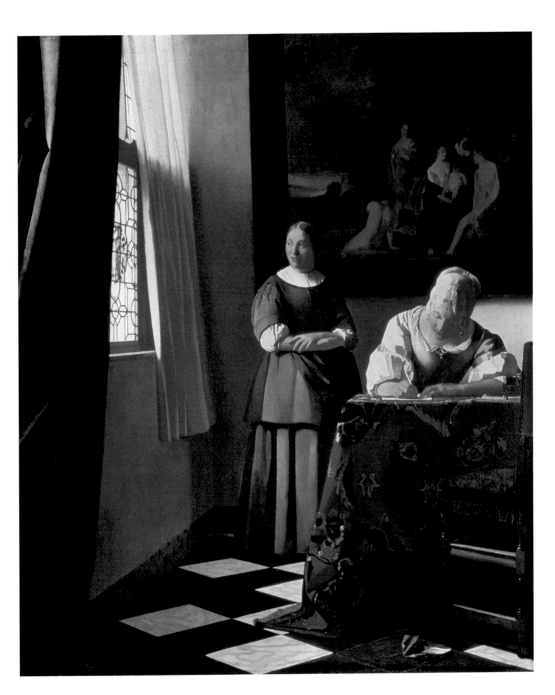

*Lady Writing a Letter
with her Maid (details)*

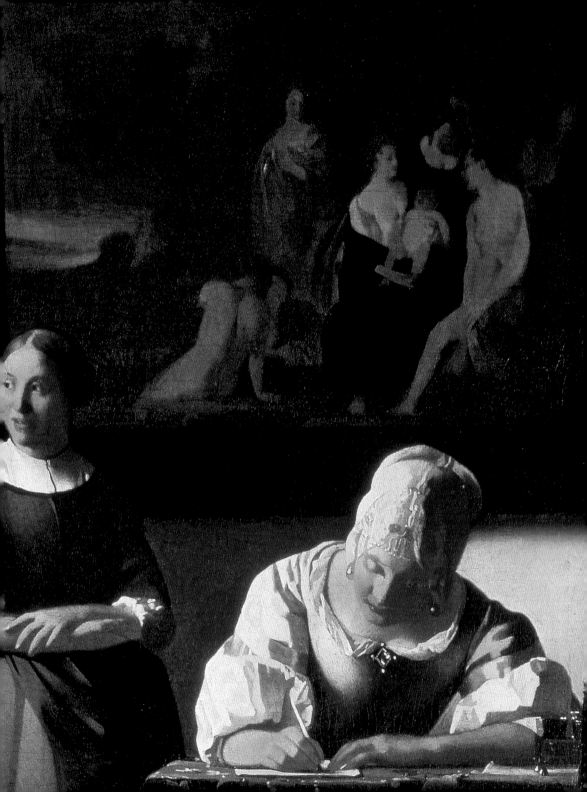

Allegory of Faith

1671–1674

Oil on canvas, 114.3 x 88.9 cm
Metropolitan Museum of Art, New York

This painting was included in the auction of Herman Stoffelsz. van Swoll's collection in Amsterdam on 22 April 1699, fetching the staggering price of 400 guilders. It then passed through various different hands until 1931, when it was left to the Metropolitan Museum in New York by Michael Friedsam. It is one of Vermeer's very late works, painted for a hypothetical and unknown Catholic patron, and its iconography is unusual for him. Some critics think the composition rather awkward, despite the very fine treatment of the details. It seems as though Vermeer found it difficult to tailor his usual, rational style, more used to realistic depictions, to expressing a religious concept such as faith. Others believe it to be an entirely successful work, perfectly able to hold its own with the new "fine painting" that was all the rage in Leiden and Amsterdam at that time. A woman dressed in an elegant gold-trimmed white and blue satin dress symbolizes Faith. In a very similar room to that depicted in the *Art of Painting*, she is portrayed beyond a richly colored curtain drawn to the left, sitting on a raised seat covered with a green and yellow rug, her right foot resting on a globe (the one made by Hendrick Hondius). With her right hand clutched to her breast, she is gazing beseechingly up at a glass orb hanging on a blue ribbon from the ceiling. On the table next to her are an open Bible, a chalice, and an ebony crucifix, which stands out against a panel picked out in gold and bronze. On the black-and-white marble floor are a symbolic apple and a snake crushed by a stone. The *Crucifixion* by Jacob Jordaens (c. 1620, private collection) hangs on the back wall. Vermeer drew some of these allegorical elements from the 1664 Dutch translation of Cesare Ripa's *Iconologia* by Dirk Pietersz. Pers, but he puts his own stamp on them, adding more still. The emphasis on the theme of the Eucharist suggests to some that the work may have been destined for the Jesuits.

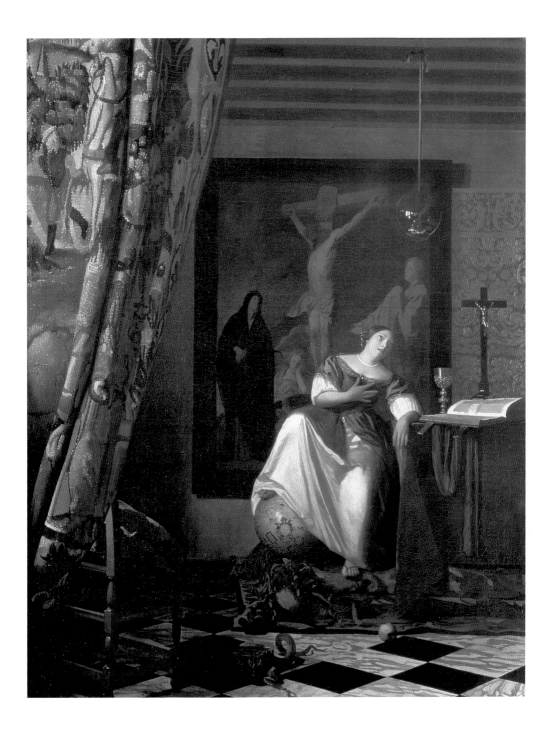

The Guitar Player

c. 1672

Oil on canvas, 53 x 46.3 cm
Iveagh Bequest, Kenwood, London
Signed right, on the bottom edge of the curtain: "IV Meer"

Listed among the possessions of Vermeer's widow in 1676, this is one of the paintings that she gave to the baker, Hendrick van Buyten, as security for a debt of 617 guilders. The other was *Lady Writing a Letter with her Maid*. The picture was included in the 1696 sale of twenty-one paintings by Vermeer as item No. 4: "A young lady playing a guitar, very good by the same [Vermeer]; 70.0 guilders." It then passed through several collections before being bought by Lord Iveagh in 1889. It is very similar to *The Lacemaker* in terms of composition, painting technique, and luminosity, and may have been painted shortly after it, though the bolder treatment has prompted suggestions that it might belong to the mid 1670s. The figure has the same then-fashionable hairstyle as the lacemaker, with a chignon and ringlets, and is clad in the same familiar luminous yellow, ermine-trimmed silk tunic. Her hands move with the same grace as those of the young woman in *The Lacemaker*, though this young woman is playing an instrument rather than sewing. She, too, is a virtuous woman, as attested to by a pile of books, possibly religious ones, on a small table in the corner of the room. Her smile expresses genuine *joie de vivre*, a mood enhanced by the sunny landscape behind her. Light floods the figure from the right, while the young woman is turning to the left, gazing into the room: it is easy to imagine an invisible listener, possibly a gallant suitor or a music master. Vermeer demonstrates his perfect mastery of the rendering of light and color, as evinced by the ermine and the silk skirt, and also by the subtly modulated back wall, simple yet superb.

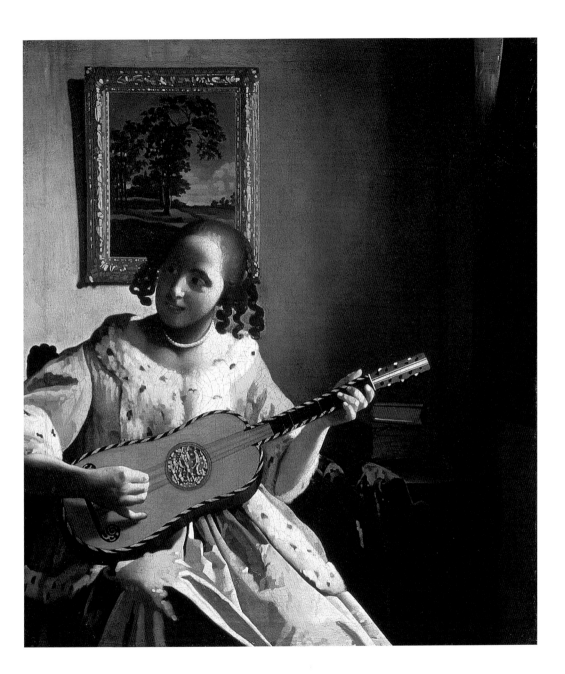

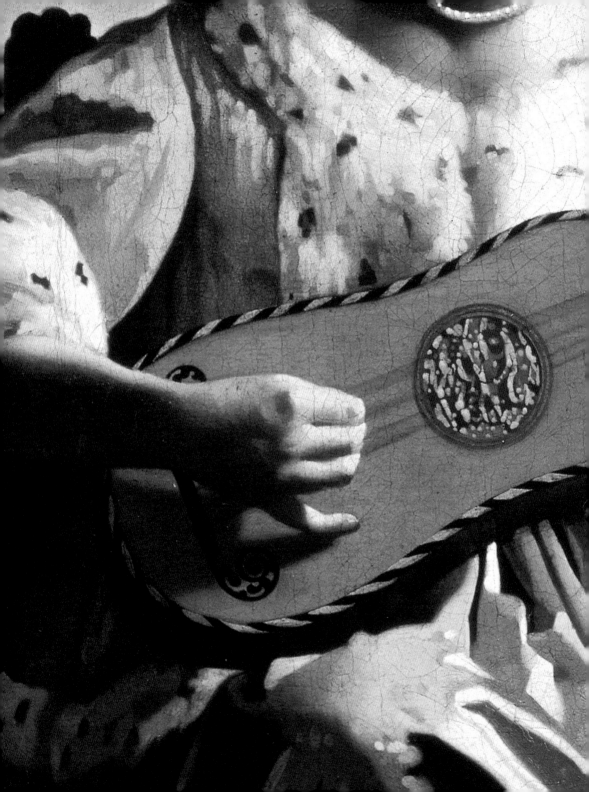

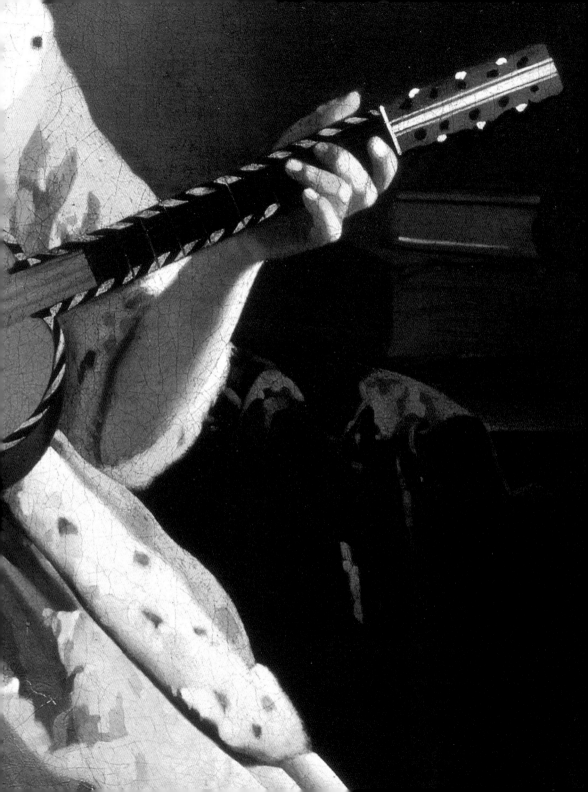

A Lady Standing at the Virginals

c. 1670–1673

Oil on canvas, 51.8 x 45.2 cm
National Gallery, London
Signed on the virginal: "IV Meer"

The painting may well have been the one in Diego Duarte's collection in Antwerp in 1682, but it is hard to tell whether it was this picture or *A Lady Sitting at the Virginals*, just as it is equally hard to tell which of the two paintings corresponds to item No. 37 in the 16 May 1696 Amsterdam auction: "A lady playing the virginals, by the same [Vermeer]; 42.10 guilders." The first definite mention of the painting was in the Amsterdam sale catalogue of 16 August 1797: "A young woman standing at a virginals, paintings hang on the walls, extremely finely painted." It was in Thoré-Bürger's collection for a while, along with *A Lady Seated at the Virginal*, passing through various hands before being purchased in December 1892 by the National Gallery in London.

Vermeer has here painted another musical scene: an elegantly dressed young woman is gracefully playing the virginals, her face turned towards the viewer. She is clearly a member of the bourgeoisie, with her sophisticated hairdo with chignon and ringlets, her blue bodice, and billowing sleeves adorned with trimmings and a multitude of small glistening pearls and ribbons. The room is also elegant, with cherubs painted on the tiles lining the skirting board (as in the kitchen in *The Milkmaid*). A blue chair stands next to the stylish virginals, with its marbleized case and painted lid. Two paintings hang on the wall: a landscape in a gold frame, broadly similar to the one in *The Guitar Player*, and a Cupid previously encountered in *A Maid Asleep*. The references of both paintings to the actual one are clear: all are united by the theme of love, which sits well with music. This is not the bawdy love of the bordello, but the chaste, pure love for one single person, as the symbolism of the playing card proffered by Cupid shows. A cold morning light filters into the room from the window on the left, creating faint shadows of the kind Vermeer alone was capable of crafting.

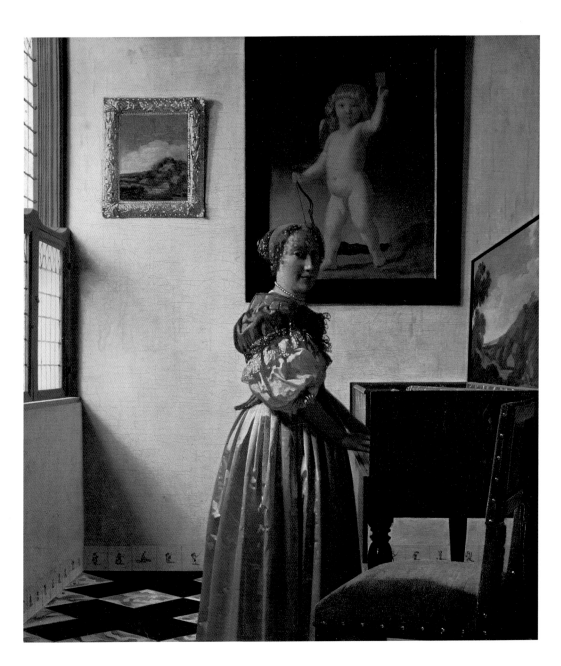

A Lady Standing at the Virginals (details)

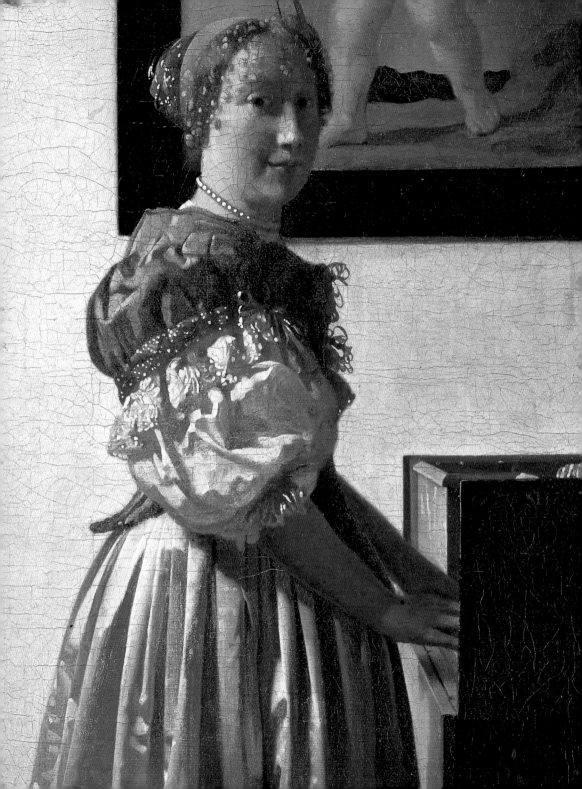

A Lady Sitting at the Virginals

c. 1670–1675

Oil on canvas, 51.5 x 45.6 cm
National Gallery, London
Signed right, next to the woman's head: "IV Meer"

This charming young lady seated at the virginals could be the younger sister of the girl in *A Lady Standing at the Virginals*. There is a family resemblance: the same elegant appearance, although the blue bodice of the older of girl has become a long over-gown, and similar hairstyles, although the hair of this girl is slightly darker. One of them is standing and the other seated: a detail not mentioned in old sources, which makes it impossible to distinguish between them.

We do not know, for instance, which of the two paintings is the one listed as "a lady playing the virginals, with accessories, by Vermeer; Price 150 guilders" in Diego Duarte's inventory for the 1682 sale in Antwerp. The painting catalogued as No. 37 in the 1696 Amsterdam auction as "A lady playing the virginals, by the same [Vermeer]; 42.10 guilders" is equally mystifying.

The grand, elegant room is in shadow. A bright light, from an unseen source behind the curtain, lights up the girl's round face, travels down over her blue satin dress, along her pale arm to the virginals, then falls brightly on the viola da gamba propped up in a corner. There is a large reproduction of Dirck van Baburen's *The Procuress* (c. 1622, Museum of Fine Arts, Boston) on the back wall, previously seen in *The Concert*. The morally profane significance of sensual love in the picture within a picture is counterbalanced by the tranquil musical scene, which is undoubtedly a metaphor for ideal love. A serene landscape is depicted inside the lid of the rectangular piano case, attributed to Peter Jansz. van Asch, a painter from Delft and one of Vermeer's contemporaries. The traditional theme, worked up by Dutch painters such as Jan Steen Gerrit Dou during the early 1670s and, earlier still, by Jan Miense Molenaer, may have provided the inspiration for this painting, although Vermeer's version takes a totally original interpretation. The closest iconographic model may have been Gerrit Dou's *Woman Playing the Virginals* (c. 1665, Dulwich Picture Gallery, London), but Vermeer's version is completely different, more immediate and succinct.

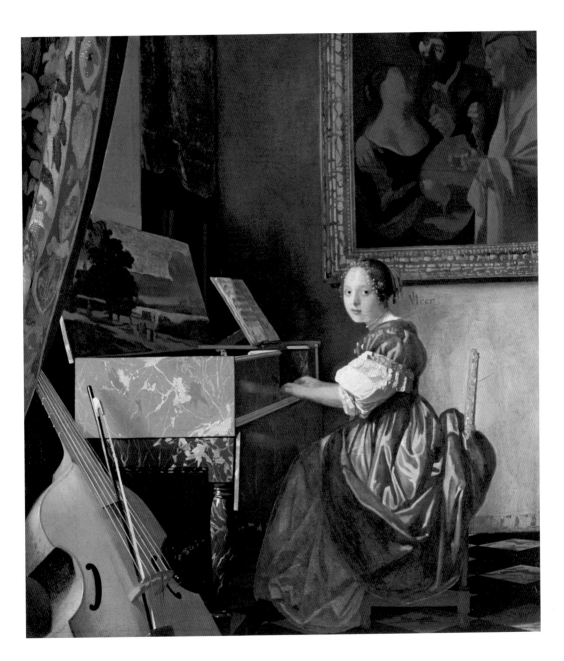

THE ARTIST AND THE MAN

Vermeer in Close-Up

The curious destiny of an overlooked Master

Vermeer's destiny was a strange one. Now regarded as one of the most brilliant and skilled painters of seventeenth-century Europe, within three years of his death he had already largely passed from memory. Samuel van Hoogstraeten, a fellow-student with Carel Fabritius under Rembrandt, made absolutely no reference to him in his extended 1678 compendium of "old school" painters, *Inleyding tot de Hooge Schoole der Schilderkonst* (*Introduction to the Academy of Painting*). In 1718 he got a brief mention in Arnold Houbraken's *De groote schouburgh der Nederlantsche konstschilders en schilderessen* (*The Great Theater of Dutch Painters*) in connection with Dirk van Bleyswijck description of the city of Delft. Just a few years earlier, however, Gérard de Lairesse had described Vermeer in his *Groot Schilderboek* (*Great Book of Painting*) of 1707 as a diligent "perspectivalist" on a par, even, with Frans van Mieris. All the eighteenth-century biographers passed over Vermeer, though he was mentioned by the English painter Sir Joshua Reynolds, who cites *The Milkmaid* in 1781, and the Dutch engraver Christiaan Josi, who had a few admiring words to spare for Vermeer in a piece he wrote in 1795. Various works by Vermeer passed through the Dutch auction houses, but he was often confused with other painters of the same name: there were at least four active under the name of "Vermeer" or "van der Meer" in Haarlem, landscape artists in particular; a "Jan van der Meer" of Utrecht, born in Schoonhoven in 1630/1635, died in Utrecht in 1688, who was a painter of narrative works and portraits; and a "Jan Baptiste van der Meiren"—all of whom tended to be confused with each other. Outside the Netherlands, however, while some enlightened collectors recognized the quality of Vermeer's work, remaining nonetheless unaware of his name, others attributed his masterpieces to better-known artists of the time, such as Frans van der Mieiris, Gabriel Metsu, or Pieter de Hooch. In 1783, for instance, a painting that may have been Vermeer's *Girl Reading a Letter at an Open Window* was ascribed to "Govaert Flinck." The situation remained unchanged until the first half of the nineteenth century, when Dutch art historians Roeland van Eynden and Adrian van der Willigen, in their survey of Dutch art, rather curiously dubbed Vermeer "the Titian of Dutch painting," reiterating the rather scant information then available without probing any further.

Things were destined to change in the mid nineteenth century, however. Critics and writers from Théophile Gautier to Charles Blanc, Edmond and Jules de Goncourt, and Marcel Proust suddenly became aware of Vermeer. "A confoundedly original master" was how the Goncourt brothers described him in their *Journal* in 1861. Even Vincent van Gogh sang the praises of his palette of colors in a letter to Émile Bernard in 1877, and the French artist and writer Eugène Fromentin called him "a keen observer" of his own country in *Les Maîtres d'Autrefois* (*The Masters of Past Time*) in 1877. However, the man generally credited with discovering Vermeer was Étienne-Joseph-Théophile Thoré (1807–1869), a lawyer and militant Socialist who became an art critic during his exile in the Netherlands, after the political unrest in France in 1848, under the pseudonym William Bürger ("citizen"), hence the name Thoré-Bürger. One of his greatest goals was to bring Vermeer to clear prominence, having admired his *View of Delft* since first seeing it in 1842. Between 1858 and 1860, he wrote several essays on Dutch painters and in 1866 published three articles on Vermeer in the *Gazette des Beaux-Arts*, fifty-eight pages of unbridled enthusiasm. Vermeer's rehabilitation took quite some time, however: in 1874 Jacob Burckhardt made little mention of him in his three confer-

ences on "Dutch Genre Painters," believing his studies of women reading or writing letters to be "overvalued." But developments in art itself were also significant, with the Impressionists' fascination with color and light, as well as their preference for subjects taken from everyday life, helping to bring Vermeer to the fore. In 1888 the French critic Henry Havard published a major monograph on Vermeer, with a more accurate catalogue than that produced by Thoré-Bürger, who had left out many works not pertinent to his study.

By the end of the nineteenth century, Vermeer was in the ascendant, his works sought-after, appreciated, valued: they shot up in price. Twentieth-century scholars analyzed his works in great detail, trying to establish an authentic corpus, while the art market, particularly in France, was flooded with dozens of "new Vermeers," all either wrongly attributed to him or outright fakes.

Van Meegeren and fake "Vermeers"

The extraordinary story of Henricus Antonius van Meegeren, a talented Dutch artist born in Deventer in 1889, has all the character of a farce. He studied at the Delft Technical Institute, where he learned the techniques for imitating the Old Masters from the restorer Theo van Wijngaarden, becoming very skilled. He invented a technique for distressing paintings and making them resemble seventeenth-century works, by which he was fascinated. One day he took it into his head to "make a Vermeer," the most enigmatic of all painters, using an authentic seventeenth-century canvas that was, unusually, still on its original stretcher; he removed a seventeenth-century painting of the Resurrection of Lazarus, leaving only the bottom layer of pigment with its craquelure. He also cut down the size of the canvas, keeping a fragment of the material as proof of his forgery. Then, using original seventeenth-cen-

tury pigments tracked down on the market and mixed with his own special thinner, he painted a *Supper at Emmaus* that he then baked at 150 degrees for two hours. The result was so astonishing that the painting, further distressed, might well have fooled those very critics who during the 1930s were striving so hard to find Vermeer's hand in a number of religious and mythological works (*Christ in the House of Martha and Mary*, *Diana and her Companions*, and *The Procuress*, the latter a genre painting). It was entirely reasonable to suppose that other paintings of the same type must also have existed, and would have appealed to certain Dutch critics and museum directors, underpinning their theories. Despite the now rather obvious stylistic differences from Vermeer's style—van Meegeren's figures have typically modern features, notably tired eyes, plump lips, stubby hands, and so on—his *Supper at Emmaus*, now in the Boymans-van Beuningen Museum in Rotterdam, managed to fool famous art historians such as the Dutchman Abraham Bredius, who wrote an article about it in the November 1937 edition of the *Burlington Magazine*.

Despite a negative response from various more astute observers (one called the work "a miserable fake"), the Boymans Museum acquired the painting for 550,000 guilders. Numerous "Vermeers" found their way onto the Old Masters market between 1939 and 1940, all manufactured by van Meegeren and all fetching huge sums from prestigious museums and private collectors. One painting ended up in the hands of *Reichsmarschall* Hermann Goering (*Christ with the Woman taken in Adultery*, Rijksdienst Beeldende Kunst, The Hague), a fact that eventually led to van Meegeren's arrest, accused of collaborating with the enemy. Facing such a serious charge, he finally confessed that he was the author of all those "Vermeers," leaving the

reputations of critics and museum directors in tatters and failing to save himself from a further sentence for fraud, despite—ironically—salvaging his own reputation. He died of a heart attack on 29 December 1947, before beginning his prison sentence. The fact remains that there were still various experts, including the Belgian Jean Decoen, who swore that several paintings ascribed to van Meegeren were in fact by Vermeer.

Vermeer's technique

Vermeer painted in the old Dutch manner, applying thin layers of oil-diluted *velatura* (semi-opaque glazes) after priming the canvas dark-brown. He built up his paintings slowly, layer upon thin layer, with each being given a glaze before the next layer was applied. He often altered his compositions as he worked, adding or removing figures and objects, changing poses and positions, as shown by the pentimenti revealed by X-ray. Like all Delft artists, he studied the effects of light closely, with surprising results. The extraordinary luminosity of his *View of Delft*, one of the paintings most admired by his contemporaries and most highly valued by posterity, is extraordinary and may have been achieved, in the manner of Peter Paul Rubens, by using a tempera or watercolor ground to which were applied successive layers of oil paint and glaze. Vermeer sometimes dabbed tiny dots of pigment on the canvas in a sort of *pointillage avant la lettre* in order to better render the roughness of the surfaces, such as the bricks of Delft houses, the bread in *The Milkmaid*, and the lace collar of *The Lacemaker*. In order to render the consistency and sheen of fabrics, at which he excelled as the son of a skillful *caffa* weaver, he blurred outlines, blending the pigments into each other, as in the ermine trim on the yellow jacket worn in *A Lady Writing*, the blue skirt in *Young Woman with*

a Water Pitcher, and the blue tunic in *Woman in Blue Reading a Letter*. It is an almost imperceptible blurring, a subtle "scumble" that serves to emphasize the outlines of the faces and objects, highlighting them with delicate auras of light. He was able to create a luminosity that plays on various tones to capture every single detail, rendered with the meticulous skill of a goldsmith, yet culminating in an overall effect of extraordinary unity and harmony.

Light and shade formed another major component of Vermeer's rendering of space. It was his mastery of this, alongside his treatment of light, that brought unity to his paintings and that earned him the admiration of his contemporaries. On 14 May 1669, Pieter Teding van Berckhout paid a visit to Vermeer's studio, concluding that the latter's special skill lay largely in his treatment of "perspective." Vermeer was not the only painter in the Netherlands to make an informed use of perspectival rules: others include Nicolaes Maes, Pieter de Hooch, Gerard ter Borch, and Gabriel Metsu, all fine artists. The Dutch painters employed perspective in a bid for realism, because what their nationalistic bourgeois patrons wanted was to be able to see their own fine houses artworks. Unlike his fellow-artists, however, Vermeer's strength lay in being able to conveying smaller, more intimate spaces, literally quiet corner. While Pieter de Hooch, also an exceptional painter, simply depicted a house and its rooms, Vermeer brought them to life for his viewers. The first thing one feels when looking at one of Vermeer's interiors, in fact, is that one is part of the painted scene, on the threshold of the room. It is almost as if a seventeenth-century stage set were suddenly opening up in front of us, with young women making music, reading, sewing, or drinking wine. Depicted with deep, skillful perspectives, the spacious, tranquil rooms with their checkered floors and elegant windows draw in the spec-

tator, who seems to look on from behind a drape or curtain. Vermeer's everyday seventeenth-century scenes were often set in corners rather than entire rooms. Yet we feel a part of them, that we are in the room along with the young lady playing the virginals or the faintly bored looking girl posing in *The Art of Painting*.

It has been suggested that Vermeer employed optical instruments, such as the camera obscura (one made by Cornelis Drebbel was brought to the Netherlands by Constantijn Huygens in 1622), or Galileo's telescope. Given that other painters, such as the *vedutista* (painter of city views) Jan van der Heyden, used them, Vermeer may very well have devised his own optical chamber, a sort of "box" with lenses and a translucent screen for visualizing scenes. Vermeer was a close friend of the scientist Anthonij van Leeuwenhoeck (1632–1723), a specialist in optics, who would have been in a position both to advise him and to provide him with the requisite equipment. Although a great many treatises on optics and perspective were circulating in the Netherlands and the rest of Europe, and would undoubtedly have been studied and consulted, the evolution of the natural sciences in the Dutch Republic spurred artists to experiment with faster ways of making their perspectival *vedute* (city views) as natural as possible. Samuel van Hoogstraeten, who built his own cameras obscura, wrote in 1678, for instance: "I am certain that the sight of these reflections in the darkness can be very illuminating for the young painter's vision; for besides acquiring knowledge of nature, one also sees here the overall aspect that a truly natural painting should have." Vermeer must also have employed optical devices, given some of his distorted shapes, compositions, and certain luminous effects, though without compromising his freedom of expression.

An unusual pictorial antechamber

Although *The Love Letter* in the Rijksmuseum in Amsterdam slots perfectly into Vermeer's oeuvre, it is also unique. It is the only time Vermeer employed the perspectival expedient of the darkened antechamber in the foreground. The room is slightly untidy: a book of music lies open on the chair, along with cloths draped over a chair, and the entire painting is suggestive of an activity recently broken off. The device of the antechamber allows for a completely innovative use of light and shade. In other works (*Lady Writing a Letter with her Maid*, *Allegory of Faith*, and *The Art of Painting*), Vermeer has used drawn-back drapes in the manner of a stage curtain, but without really differentiating between the place where the action is occurring and that of the observer. In this case, however, Vermeer has introduced the device of a sequential series of spaces. It is interesting to compare them with the interiors painted by Pieter de Hooch, and in particular with his *Couple with Parrot* (1668, Wallraf Richartz Museum, Cologne). This work is very similar to Vermeer's *The Love Letter* in terms of composition, lighting, and perspective, as exemplified above all by the same geometric pattern of the black-and-white patterned tiles. Vermeer's picture even includes a broom, presumably abandoned by a hurried maid, in the darkened foreground. A written reference to a visit to Vermeer by the aforementioned Pieter Teding van Berckhout, in which he noted that he had admired several examples of his art, "of which the most extraordinary and curious parts consists in the perspectives," could well bear this out. In 1995 Jørgen Wadum undertook a reconstruction of the instruments and techniques used by Vermeer to render perspective, taking as his starting point the presence of a tiny pinhole in many of the canvases—strings attached to a pin at the vanishing point would have helped the artist to determine the correct orthogonals. He also dis-

cussed the relationship between Vermeer and de Hooch: "At the beginning of his career Vermeer had difficulty in rendering floor tiles. The distance points, positioned at an equal distance on either side of the vanishing point on the horizon, provided the basis for the diagonals. These lines form the pattern of the floor tiles. When the horizon of his painting was relatively high and the distance points were close to the vanishing point, Vermeer apparently was vexed by the distortion of the tiles at the foreground corners. [...] As Vermeer's career progressed, he solved this problem by moving the distance points farther away from the scene, thereby eliminating the distortion. This is important, particularly as he moved his vanishing point toward the edge of the painting at the same time. [..] In *The Love Letter*, the angle declines to about 28°, and in the last painting executed by his hand, *A Lady Seated at the Virginal* [...] Vermeer reduces the viewing angle to only 22° [...] It is interesting to note that Vermeer painted only diagonally placed floor tiles in his interiors, while De Hooch used diagonally placed as well as parallel tiles—sometimes even both within one painting, at random intervals." Jørgen Wadum, *Vermeer in Perspective*, in *Johannes Vermeer*, ed. Arthur K. Wheelock, Jr., 1995.

Works by Vermeer in the Dissius Collection

The following is the list of twenty-one paintings by Vermeer included in the "Catalogue of paintings sold on 16 May 1696 in Amsterdam": 1) A young lady weighing gold, in a box, by J. Van der Meer of Delft, extraordinarily artful and vigorous; 155.0 guilders; / 2) A maid pouring out milk, extremely well done, by the same; 175.0 guilders; / 3) The portrait of Vermeer in a room with various accessories, uncommonly beautiful, painted by him; 45.0 guilders; / 4) A young lady playing a guitar, very good by the same; 70.0 guilders; / 5) In which a gentleman is washing his hands in a perspectival room with figures, artful and rare, by the same; 95.0 guilders; / 6) A young lady playing the virginals in a room, with a listening gentleman, by the same; 80.0 guilders; / 7) A young lady who is being brought a letter by a maid, by the same; 70.0 guilders; / 8) A drunken maid sleeping at a table, by the same; 62.0 guilders ; / 9) A gay company in a room, vigorous and good, by the same; 73.0 guilders; / 10) A gentleman and a young lady making music in a room, by the same; 81.0 guilders; / 11) A soldier with a laughing girl, very beautiful, by the same; 44.10 guilders; /12) A young lady doing needlework, by the same; 28.0 guilders / 31) The Town of Delft in perspective, seen from the south, by J. Van der Meer of Delft; 200.0 guilders; / 32) A view of a house standing in Delft, by the same; 72.10 guilders; / 33) A view of some houses, by the same; 48.0 guilders; / 35) A young lady writing, very good, by the same; 63.0 guilders; / 36) A lady adorning herself, very beautiful, by the same; 30.0 guilders; / 37) A lady playing the virginals, by the same; 42.10 guilders; / 38) A *tronie* in antique dress, uncommonly artful, by the same; 36 guilders; / 39) Another one by the same; 17.0 guilders; / 40) A pendant by the same; 17.0 guilders.

Vermeer's wealthy clientele

Vermeer's career spanned twenty years, from the mid 1650s to the mid 1670s, during which time he must have painted around fifty pictures, possibly two or three a year. He probably worked for several clients who lent him money in return for paintings. One of his clients was the wealthy baker Hendrick van Buyten (1632–1701), his contemporary and a friend of the family, who agreed to take two of Vermeer's paintings from his widow as surety against a debt of 617 guilders for one or two years' worth of bread (de-

pending on whether the bread was white or brown). It took a lot of bread to feed eleven children, a wife and a mother-in-law, though the latter contributed generously to the family's upkeep. The two paintings that Vermeer's widow pledged are thought to have been *Lady Writing a Letter with her Maid* and *The Guitar Player*. Van Buyten undoubtedly owned other works by Vermeer, one of which had been seen in his shop by Monsieur de Monconijs in 1663, who judged 600 livres too high a price for a painting with only a single figure.

Another of his clients may have been the wealthy burgher Pieter Claesz. van Ruijven (1624–1674), whose name was discovered in the course of archival research by John Michael Montias. Vermeer had borrowed 200 guilders from him on 30 November 1657. It is thought that he may well have repaid him in paintings, as with the baker. In actual fact, there is no mention of paintings in the document in which Vermeer and Catharina undertook to repay the money within the space of a year, which specified that in the event of their being unable so to do, they agreed to be "sentenced by the city judges." Van Ruijven had made his money from legacies and investments, but played no major political role in the city. On his death, his collection of paintings passed to his daughter Magdalena, and on her death to her husband Jacob Dissius. Dissius owned a print shop in the market square in Delft, and decided to put the paintings up for sale in Amsterdam on 16 May 1696. The collection included some twenty paintings by Vermeer, which may have been acquired by van Ruijven, but equally by his daughter or Dissius himself. These works now make up the oldest known corpus of Vermeer's paintings.

The archives also yielded up other names. An occasional patron may have been Nicolaes van Assendelft (1630–1692), a regent of Delft, who acquired numerous works by contemporary artists during his lifetime. Mention is made in the 1711 inventory of his wife's belongings of "a young lady playing the virginals by Vermeer" valued at 40 guilders, possibly identifiable as *A Lady Standing at the Virginals*. We do not know, however, whether or not van Assendelft bought the painting directly from the artist.

Another Vermeer collector may have been the scientist Antonij van Leeuwenhoeck, for whom he presumably painted *The Astronomer* and *The Geographer*. Van Leeuwenhoeck was later assigned the difficult task of overseeing Vermeer's legacy and the consequences of the bankruptcy. As he is thought to have been a friend of Vermeer's, being of much the same age and a fellow-citizen, it is perfectly possible that he may have commissioned paintings from him. A cloth merchant by trade, Van Leeuwenhoeck was passionate about constructing scientific instruments. Self-taught, he became internationally renowned as a grinder of lenses, producing several hundred. He put together complicated mounting systems and combinations of lenses, producing the first microscopes capable of enlarging objects to the power of 500. He was extremely well-versed in anatomy and zoology, carrying out ground-breaking research, the results of which he started sending in letter form to the Royal Society in London as of 1763, gradually establishing a reputation as one of Europe's leading scientists. His relationship with an artist like Vermeer, a man equally complex and sophisticated, must have been far more intense than surviving documentation is able to convey.

Vermeer doubtless had a broader and more organized client base and range of activities than at first appears. A large number must have come and gone around his studio—rich members of the bourgeoisie, patricians, dignitaries, connoisseurs, and travellers, as demonstrated by

the visit of the French diplomat Balthasar de Monconys in 1663 and the visits, in May and June 1669, of Teding van Berckhout, a wealthy man from The Hague who was related to the Huygens family. His visit was presumably made at the suggestion of Constantijn Huygens (1596–1687), Secretary to the *Statolder* Frederick Henry, Prince of Orange; an intellectual and influential political figure, Huygens certainly knew Vermeer. Constantijn Huygens was the man who discovered the "noble pair" Rembrandt and Jan Lievens in Leiden, had contacts with Peter Paul Rubens and Anthony van Dyck, and was prominent among cultured and fashionable society in The Hague. Vermeer's studio would therefore have been an obligatory stop on his itinerary, like those of Dou and Mieris.

Paintings, linen, pots and pans

What would Vermeer's studio in Maria Thins' house in what was known as the Papenhoek (Papists' Corner) have been like? The answer may lie in the room depicted in *The Art of Painting*, with the familiar curtain in front of an entrance offering a glimpse of the interior: a map on the wall, a beamed ceiling, a fine chandelier, a table laden with fabric, a sketchbook and a male mask, chairs, and an easel. It may have been exactly like this, or indeed entirely different, we have no way of knowing. However, there is an inventory dated February 1676, drawn up two months after his death, that describes the studio and tells us what was in it. It took up two rooms on the second floor of the house. One of the rooms, which had an outside window, was the studio itself, with thirty or so books, two "Spanish chairs," an ivory-handled cane, two easels, three palettes, ten or so canvases and six panels, three bundles of prints, and a desk. There were also clothes and costumes, such as the yellow satin fur-trimmed jacket that features in six of his paintings; and

a wooden box with drawers in which, like many masters of the time, he kept his painting materials, and as depicted in Gonzales Coques's *Painter's Studio* (c. 1650, Staatliche Museum, Schwerin). Vermeer would have purchased his materials from a specialist supplier in either Delft or nearby Rotterdam. We know that he owed money for medical supplies to the pharmacist D. de Cock, whose inventory lists substances used in the preparation of varnishes and colors, such as massicot, a yellow lead-based pigment, and tin, used in the yellow of the fur-trimmed jacket, as well as turpentine, linseed oil, and so on. The small adjacent room contained more books, as well as a stone slab and pestle for grinding pigments in the loft just above.

The house of Maria Thins, which belonged to her cousin, was in the Papenhoek, between the Oude Langendijck canal and the Molenpoort, in an area populated primarily by Catholics; it was also an area noted for craftsmen and artists, such as the painter Jacob Jansz. van Velsen (c. 1597–1656) and the sculptor Adriaen Samuels. The exterior of the house can still be seen, with some additions, in an eighteenth-century drawing by Abraham Rademaecker, while the interior is described in the inventory which, in addition to the eleven rooms, mentions furniture, kitchen utensils, and utility areas such as the "basement room" and "little hanging room." The family lived on the first floor, beneath Vermeer's studio, which was reached by a staircase. Almost all the walls were hung with pictures: a still life with fruit, a seascape, a work by Carel Fabritius, an Apollo, and six other unspecified paintings hung in the "front hall," on the first floor. Other paintings of various subjects hung in the "great hall," or drawing room, including a good many family portraits. The house had two kitchens, with beds and a large *Christ on the Cross*. The basement room, used as a bedroom, contained another *Christ on the*

Cross and a "woman with a necklace" by Vermeer, possibly the Berlin *Woman with a Pearl Necklace*. There was also the family linen, shirts, aprons, nightshirts, no less than twenty-one children's shirts, twenty-eight bonnets, and eleven children's collars, as well as twenty ruffs and thirteen pairs of fancy cuffs belonging to Vermeer, the trappings of a middle-class gentleman. Last of all, there were pots and pans, and cradles, as in any home full of children.

The magic of an earring

It was this house, along with Vermeer's masterpiece *The Girl with a Pearl Earring*, that inspired the enchanting novel of the same name by the American novelist Tracy Chevalier. Published in 1999, the novel formed the basis for the 2003 film with the same title, *Girl with a Pearl Earring*. Directed by Peter Webber, the film is set in seventeenth-century Delft, with its market-square, narrow alleyways, canals, the Oude Kerk and the Nieuwe Kerk. The scene is the house of Maria Thins, where the painter, his wife, and children—four girls and two boys at the start of the film, with more to follow—a couple of maids, the grumpy, prickly twenty-eight-year-old Tanneke, cook and heavy-duty maid, and the young, beautiful sixteen-year-old Griet. The latter, the central character, is the daughter of a tile decorator blinded by an accident at work. The members of both families revolve around her—her own modest Protestant family, who live in a down-at-heel district of the city, and the bourgeois Catholic Vermeer family, with their house on Oude Langendijck, on the corner of the Molenpoort, in the Papenhoek. Griet has a brother, Frans, an apprentice decorator in a factory out of town, and a younger sister, Agnes, destined to die of the plague. Griet is forced to go into service with a wealthy family in order to help ease her family's financial plight. She happens to meet Vermeer, who is casting about for help for his wife, Catharina, in the period before yet another birth.

There is an immediate spark between the artist and the girl with the large intelligent eyes. The entire narrative revolves around this unspoken mutual attraction, which is never openly expressed, and only hinted at towards the end when the painter strokes the girl's face timidly as she cries with pain after piercing her ear. A tacit rapport, built on looks and measured gestures, is immediately established within this uneasy environment, dominated by the watchful Maria Thins and the jealous, and permanently pregnant, Catharina, who is insensitive to the demands of her husband's métier and eventually goes so far as to forbid Griet from entering his studio. Griet's life consists of buying meat and fish at the market, washing the sheets, and trying to take care of four often difficult children. Vermeer is focused on finding the perfect light and ideal setting for his paintings, wrapped up in a world of his own, spent either painting or at the Guild of St Luke. He soon finds a potential "collaborator" in Griet, who turns out to be good at purchasing and grinding his colors and keeping his studio clean, without disturbing his things and occasionally even coming up with suggestions. Griet keeps watch from the small loft above the studio, next to her "master," secretly following the inception, evolution, and gradual completion of each painting, and working out lighting effects and perspectives for herself. Eventually, she becomes the model for a painting, *The Girl with a Pearl Earring*, destined for the rich but coarse collector, van Ruijven, who does not pass up the chance to molest the girl, but gets away with it because he is one of Vermeer's most important clients. Griet poses at length, gazing at her face on the easel, day and night, until she realizes that the luminosity of the painting lacks something: a pearl earring.

She has to pierce her own ears, a painful process, and then secretly don Catharina's earrings. Although she loves Vermeer, she preserves her sanity by taking up with a butcher's son of whom her parents, finally able to get their hands on a bit of meat, approve. When Catharina discovers that her earrings have been worn by the girl secretly being painted by her husband, she throws her out, believing that this constitutes certain proof that something is going on between them. Griet marries the butcher's son and has two children. She tries to forget Vermeer, who leaves it to his wife to give Griet the pair of pearl earrings on his premature death. Griet sells the earrings, using the money to pay off the Vermeer family's debt for the supply of meat.

A simple plot, but a fascinating one in terms of the interweaving of the various strands, drawn from actual documents, and the way they inform the narrative. The difficult relationship between the Protestant Griet and the Catholic Vermeer family provides the backdrop for the story, as illustrated by Griet's discomfort and naïve reactions when she comes across the two paintings of *Christ on the Cross* in the house, one in the basement and the other in the drawing room.

A far-sighted mother-in-law

Vermeer, who had twice been Dean of the Guild of St Luke, and had several sources of income, died in debt. The main trigger seems to have been the war waged by the French king Louis XIV in the Netherlands and Vermeer's ensuing financial collapse. His widow made this plain when asking the Dutch High Court for a moratorium on the debts, arguing that during the war her husband "had earned very little, practically nothing" from his paintings and that he was also unable to sell pictures by other artists. Some art historians, such as Daniel Arasse, have wondered whether

Vermeer's final financial collapse was actually triggered by the inability to sell his own paintings, given that his art dealings never seem to have been his greatest source of income. He did, in fact, paint very slowly and so did not produce many works. It is true that he asked a lot for them and probably did earn more by selling other people's work, although a mere twenty-six paintings were found in his studio after his death, worth around 500 guilders overall, which works out at 40 guilders per painting. When the artists and art dealer Gerrit Uylenburgh (c. 1625–1679), went bankrupt, by comparison, he had roughly 100 paintings in store, all worth some 100 guilders apiece. Yet Vermeer lived a comfortable and apparently well-to-do life, which allowed him to paint without having to work for a living. This may well have been due to his mother-in-law, Maria Thins, who had put all her assets at the disposal of her daughter's family, and who, after her initial doubts, seems to have got on well with her son-in-law. She did, in fact, make substantial loans to the couple, as shown by the six wills that she made between 1657 and her death, at the age of eighty-seven, in 1680. Take the first of these, for example, dated 1657, in which Maria relieved Catharina and Vermeer from repaying the loan of 300 guilders she had made to them a year earlier. She left 200 guilders to her niece and goddaughter, Maria, and jewelry, silverware, furniture, and linen to her daughter Catharina. All her property, securities, and credits were to be divided between Catharina's children, "born or unborn," apart from the heirship of her two living children, Catharina and the reprobate Willem, who was unmarried. Maria Thins was extraordinarily fond of her eleven surviving grandchildren. Maria, the eldest, and another three or four sisters, had been born by 1663; Johannes was born in 1663 or 1664; and Ignatius, the last but one, around 1672.

Various art historians have tried to find out what happened to Vermeer's children, none of whom seems to have been interested in art. Johannes, the eldest boy, had been educated courtesy of his grandmother, for instance. He married Anna Frank, who gave birth to a child in Rotterdam on 25 October 1688, two months before Catharina died. On inheriting "Bon Repas," a domain of ten and a half *jugers* (around twenty-two acres) near Schoonhoven as the eldest son, Johannes left the Dutch Republic forever. No more was known of him until his son Jan, an illiterate weaver, registered "Bon Repas" in his own name following the "presumed death of his father."

A "Jesuit" allegory

The Dutch Republic was a Calvinist country, as was Vermeer's original family. It would appear that his wife's family belonged to the Catholic minority, a fact confirmed by their setting up home in the Catholic Papenhoek of Delft in 1641. The house was sold by Hendrick van der Veldt, a lay Catholic, to Jan Geensz. Thins, the cousin of Maria Thins, that same year. Vermeer and Catharine were married by a Jesuit at Schipluy (now Schipluiden), a very Catholic town. Although no documentary proof exists, it is thought that Vermeer must have converted to Catholicism between 5 and 20 April 1653, presumably to put his mother-in-law's mind at rest. Apparently Maria Thins refused to sign the marriage certificate, though she was resigned to the marriage. The fact that Vermeer then moved into his mother-in-law's house in the Papenhoek is probably an indication that Vermeer had become a Catholic for financial rather than deeply religious reasons. There are no elements in his oeuvre that might suggest Catholic leanings, and the fact that there were two paintings of Crucifixions by other artists in the house can easily be attributed to his art dealings. In actual fact, Vermeer's religious beliefs are an enigma. Only one painting on a religious theme, the *Allegory of Faith*, exists, a late work dating from 1671–1674. For whom might he have painted? It was initially thought to have been commissioned by the Delft Jesuits, then possibly by an anonymous private client, who may have been his only Catholic patron, because all the others were Protestants. Efforts to establish his identity have been thwarted, especially as the painting formed part of the collection of the late Herman Stoffelsz. van Swoll (1632–1698), head of the Bank of Hamburg and a Protestant; it was auctioned in Amsterdam on 22 April 1699, fetching 400 guilders. The scene is set in a seventeenth-century Dutch interior, which some people have taken to be one of the "hidden churches" inside secular buildings where the Delft Catholics were forced to worship. Thus it may well represent a "real" allegory, set in a specific location: an ambitious endeavor, in which Vermeer seems to have been embarking on an entirely new genre, presenting allegories within domestic interiors, as in *The Art of Painting*. His *Allegory of Faith* contains a wealth of symbols of clear Catholic resonance, such as the splendid glass orb hanging on a blue ribbon from the ceiling, a focus for religious contemplation. The orb, which does not feature in Ripa's *Iconologia*, from which most of the symbolic elements of the painting are drawn, comes from a book of symbolic figures published by the Jesuit Willem Hesius in Antwerp in 1636, *Emblemata sacra de fide, spe, charitate* (*Sacred Emblems of Faith, Hope, and Charity*). The orb is said to represent the immensity of the human soul when it has "faith" and so "is greater than the greatest world." Whether or not this motif chimed with Vermeer's beliefs has yet to be demonstrated, nor does it seem particularly important. A slight "doctrinal" or "programmatic" quality to the work suggests an effort to conform to an unfamiliar iconography,

though the details, such as the curtain—a tapestry that acts as a theatrical curtain—the chalice, the book, the globe, and the wooden crucifix are all superbly rendered.

History, geography, and painting

One of Vermeer's most frequently discussed paintings with regard to the interpretation of symbolic meanings is *The Art of Painting*, a medium-sized work executed around 1666, which remained in his house until he died. It depicts a young model in the guise of Clio, the Muse of History, this transformation of a young woman into a Muse suggesting a lifting of the studio and the artist from the mundane to the ideal realm. There have been countless readings of the picture, one of the most interesting being that by Hermann Ulrich Asemissen (*Jan Vermeer. Die Malkunst*, 1988) who, based on the Statutes of the Guild of St Luke in Delft, managed to identify many of the objects surrounding the artist as "symbols of the trades with which painting was associated under the aegis of the Guild of St Luke." Daniel Arasse (*Vermeer: Faith in Painting*, 1996) came up with a different interpretation, focusing on the prominence of the map and the girl, suggesting that the artist may have been hoping with this work, with its supreme technical mastery and originality, to establish his claim to fame. This was his *ars poetica*. The map, signed rather significantly by Vermeer, is a reproduction of the map of the Netherlands by Claes Jansz. Visscher, published after his death in 1652 by his son. It shows the Seven United Protestant Provinces in the North (on the right), and the ten still under the Spanish Habsburgs in the South. The map in the painting represents the scientific discovery of a territory, its *nova descriptio* ("new description"), as he inscribed on the map itself, which introduced hitherto unknown faraway places and countries, just like the art of painting,

which makes the absent present. The juxtaposition of geography and painting is an ancient one, going back to Ptolomy (1st/2nd century AD). During the seventeenth century, cartography was also bound up with history, as stressed by the Dutch cartographer Joan Blaeu (1596–1673), who dedicated his twelve-volume *Atlas* to Louis XIV in 1663 with the words "geography is the eye and the light of history," in other words geography "illustrates" what history relates. Clio, the Muse of History, is posing in front of the large, splendid map, which has twenty views of Dutch cities along the borders with subtle political implications. Thus painting becomes "demonstrated knowledge" under three headings, history, geography, and cartography, and therefore a truly noble art. Vermeer painted another four maps in his pictures with a meticulousness that set him apart from his contemporaries. His maps really are pictures in their own right, not just descriptive or realistic accessories. The two maps showing the provinces of Holland and West Friesland in *Officer and Laughing Girl* and *Woman in Blue Reading a Letter* are, in fact, the same map, published in 1620. However much their treatment differs in terms of size and tonality, they are genuine works of art in particular contexts. The map in *The Art of Painting*, for instance, is shown complete with creases, craquelure, undulations, and protuberances that enable the artist to play with the subtleties of the depiction of light—a subtlety that develops progressively from the first map depicted in *Officer and Laughing Girl* right up to the one shown in *The Art of Painting*, taking in *Woman in Blue Reading a Letter*, *Woman with a Lute*, and *Young Woman with a Water Pitcher* along the way. Light is symbolic of Vermeer's work, endowing his objects with an extraordinary luminosity, a quality for which he was renowned from the eighteenth century onwards.

Vermeer and the twentieth century

The twentieth century saw the enthusiastic rediscovery of Vermeer. American collectors such as John Pierpont Morgan and Isabel Stewart Gardner were prepared to pay staggering sums in order to secure major works for export to the United States. One example is Vermeer's *Allegory of Faith*, sold in 1928 by Abraham Bredius, Director of the Mauritshuis, to an American collector for 300,000 dollars. It was the year 1935 that definitively established Vermeer as a major artist, with an exhibition in Rotterdam entitled *Vermeer: Origins and Influences*. Vermeer was elevated to the ranks of Rembrandt, while such artists as Jan Steen and Frans Hals fell slightly from grace. Unfortunately, however, six of the fifteen paintings in the exhibition were not actually by Vermeer himself, giving a somewhat false impression of his achievement. The spurious works included a *Lacemaker* and a *Smiling Girl*, by an anonymous twentieth-century artist, now stored at the National Gallery in Washington, believed by the curator of the Rotterdam exhibition, Dirk Hannema, the Director of the Berlin Museum, Willem Bode, and the Director of the Mauritshuis, Willem Matin, to be "authentic."

Dutch, German, and American art historians have made huge inroads into the study of Vermeer, with monographs such as Eduard Plietzsch's *Vermeer van Delft*, published in Charlottenberg in 1911, and Philip Leslie Hale's *Jan Vermeer of Delft*, published in Boston in 1913, followed after the war by contributions from Ary Bob de Vries, Pieter T. A. Swillens, Albert Blankert, Arthur K. Weelock, Jr., and Erik Larsen, all of whom, in their own way, sought to see Vermeer's oeuvre in its true light, free of unfounded conjectures. Further stylistic analyses followed during the 1950s, from Vitale Bloch (*All the Works of Vermeer*, 1954/1963) and André Malraux (*Vermeer de Delft*, Paris 1952), leading up to the first detailed documentary research, carried out by John Michael Montias during the 1970s ("New Documents on Vermeer and his Family," in *Oud Holland*, 91, 1977). Since then there has been a proliferation of writings, with scientific studies and also fictionalized accounts. Vermeer has become a myth, true or false as the case may be.

In the end, it is in the contemplation of the paintings themselves that we each discover Vermeer.

Anthology

Thus did this Phoenix [Carel Fabritius], to our loss, expire, In the midstand at the height of his powers, But happily there arose out of the fire Vermeer, who masterfully trod in his path.

Arnold Bon, in Dirk van Bleyswijck
Beschrijvinge der Stadt Delft, 1667

This van der Meer, of whom historians say nothing, merits special attention. He is a great painter in the manner of Metsu. His works are rare, and they are better known and appreciated in Holland than elsewhere [...]

Jean-Baptiste-Pierre Lebrun
Galerie des Peintres Flamands, 1792

It is painted with a vigor, a solidity, a firmness of impasto very rare among the Dutch landscapists. This Jan van der Meer, of whom I know nothing but the name, is a rugged painter, who proceeds with flat colors liberally applied, built up thickly [...]

Maxime du Camp
in the Revue de Paris, 1857

A confoundedly original artist, Vermeer. One might say that he represents the ideal sought by Chardin: the same milky paint, the same touch with little dabs of broken color, the same buttery texture, the same wrinkled impasto on the accessories, the same 'stippling' of blues, of bold reds in the complexions, the same pearl-grey in the background [...]

Edmond and Jules de Goncourt
Journal, 1861

In Vermeer, the light is never artificial; it is precise and natural and not even a meticulous physician could wish it to be more exact. The light seems to come from the paint itself and naive spectators could easily imagine that the light actually slips in between the canvas and the frame. One such person, entering the house of M. Double, where *Officer and Laughing Girl* was exhibited on an easel, went behind the curtain to discover the origin of the marvelous splendor from the open window. That is why black frames suit Vermeer's canvases so well.

Étienne-Joseph-Théophile Thoré
Van der Meer de Delft, 1866

Do you know a painter named Jan van der Meer? He has painted a Dutch woman, beautiful, very distinguished, who is with child. This strange artist's palette includes blue, lemon-yellow, pearl-grey, black and white. The whole range of colors can be found in some of his paintings; but the juxtaposition of lemon-yellow, faint azure, and light grey is typical of him. [...] The 17th-century Dutch had no imagination, but they had unusual taste and an infallible sense of composition.

Vincent Van Gogh
Letter to Émile Bernard, 1877

From the moment I saw *View of the Delft* at The Hague Museum, I knew that I had seen the world's most beautiful painting. In *Swann's Way*, I simply had to assign a study of Vermeer to Swann. I could not dare hope that you would have paid such resolute justice to this extraordinary master, because, being acquainted with your (rather different) views on hierarchy in art, I was afraid that you would think him too Chardinesque. It was with great joy, therefore, that I read that page. And still, I know almost nothing of Vermeer.

Marcel Proust
Letter to Jean Louis Vaudoyer, 1921

Pieter de Hooch and Terborch, both of whom specialized in painting Dutch householders, would be banal if it were not for their sensitiveness to those elusive shades of gesture and behaviour in everything that is implied by the word domesticity. Without this subtle intimacy they would be lost in the undistinguished mass of anecdotal painting to which their work gave birth. Vermeer of Delft [...] added to their subtlety subtler qualities still – a sense of the fall of subdued light in interiors so finely adjusted that a fly settling on one of his canvases would produce an intolerable disturbance in the balance of the hushed, golden tones. [...] It is puzzling to know by what process his translucent, liquid surfaces were achieved. His paint seems to have floated miraculously on to the canvas. Moreover, there is, in the painting of Vermeer, a curious aloofness, even a refusal to interest himself in the busy domestic life, crowded with trivial incident, that obsessed most of the genre painters of seventeenth-century Holland. In Vermeer [...] action is suspended. Life seems to have turned itself into still-life. The lady reading the letter or standing at the virginals is no more and no less important than the white jug that stands on the table or the cello that lies against it. It is this aristocratic stillness imposed on a world made up of domestic trivialities that makes Vermeer so fascinating and so paradoxical as a painter.

Eric Newton
European Painting and Sculpture, 1941

[...] but in one instance the rendering of atmosphere reached a point of perfection that, for sheer accuracy, has never been surpassed: Vermeer's *View*. This unique work is certainly the nearest which painting has ever come to a coloured photograph. Not only has Vermeer an uncannily true sense of tone, but he has used it with an almost in-

human detachment. He has not allowed any one point in the scene to engage his interest, but has set down everything with a complete evenness of focus. Such, at least, is our first impression of the picture and the basis of its popularity with those who do not normally care for painting. But the more we study the *View of Delft*, the more artful it becomes, the more carefully calculated its design, the more consistent in all its components. No doubt truth of tone adds to our delight, but this could not sustain us long without other qualities, and perhaps could not, by itself, have reached such a point of perfection, for the mood of heightened receptivity necessary to achieve it cannot be isolated from that tension of spirit which goes to the creation of any great work of art

Kenneth Clark
Landscape into Art, 1949

The common characteristics of all the painter's work, the remarkable order which he extracts from the world, his elaborate evasion of its human claims, suggest the imminent possibility of opposite qualities, a fearsome anarchy, a formidable, exigent principle not to be trifled with. Whether he skirts it, as he does in his earlier inconsistencies of style, or covers it with the merciful veil of light, the presence of the threat is equally clearly conveyed. It is as if he imputed to the visible world something of his own nature, the insistence with which he lays hold of a likeness, the determination with which he makes it his own. Around his central subject, the figure of a woman, to which he makes so many approaches, each complicated by a simultaneous gesture of withdrawal, an enigmatic meaning accumulates. The woman's detail, the complexity of her being, conceals a disturbing element. Examined too narrowly she will become a source of danger. The painter's style

develops along a line of self-preservation; its infinite inge-
nuity is all directed to isolating from these latent, intimate
perils the visible beauties among which they hide.

Lawrence Gowing
Vermeer, 1952

Using many of the same themes—and even many of the
same props—as other painters of his day, Vermeer construc-
ted works of art so different from theirs, so uniquely his, as
to be without parallel either in the 17th Century or in all the
years that have flowed away since then. And not the least
remarkable thing about his painting is that, far from being
merely charming or exuding an antique air, they go on living,
as though each were a split second of eternity.

Unlike other genre painters, Vermeer has no story to
tell, no moral to teach. Nor does he seem to have been
particularly imaginative. He had a single goal and was sin-
gle-minded about it—finding beauty in the normal, the par-
ticular, even the banal. With lenslike precision, he trans-
ferred to his canvas the world of the sun-filled room. For
Vermeer, light was nature's paintbrush: it not only de-
scribed the shape of things but it also bestowed upon them
their colors. He approached it reverently. Painting with the
motion of neither his arm nor his hand but with the precise
movement of his fingers, he blended his pigments so evenly
that they have the intensity of colors seen in the ground
glass of a camera, and he applied them in layers so thin
that they lay like enamel on his canvas.

Through the use of techniques like these, he managed
[...] to convey the deep feeling of serenity that is the mark
of his work.

Hans Koningsberger
The World of Vermeer, 1967

[Vermeer's] pictures give the impression that he felt the
need for an exceptional degree of control. By means of
carefully contrived designs he made things look stable and
unchanging. He kept his distance from human beings,
while reveling in texture, color, and the magical power of
light. No visible brush stroke, no trace of activity of the
artist's hand, was permitted to break the impeccable sur-
face of his pictures. Control of impulses toward sensuality
is the leitmotif of both the moral implications and the for-
mal characteristics of his paintings. Not the artist, but the
light seems to open the space and caress the figures. The
calm and stability he created responded to his inner needs.

With all his individuality, Vermeer was very much an artist
of his time and place. Like his contemporaries, he did not
hesitate to adapt existing modes and motifs from any
sources. Along with other Dutch painters, he scrutinized
the world around him and incorporated in his pictures col-
ors, shapes, and textures experienced in the visible world.
At the same time, he shared with his fellow-countrymen
a profound concern for permanent values, and his works
are dignified by the natural stance that permeates them.
His command of space representation may be understood
as a metaphor for the deeper truth with which he was re-
occupied.

Madlyn Millner Kahr
Dutch Painting in the Seventeenth Century, 1978

Vermeer's philosophy is likely to have a number of com-
ponents. Almost certainly its character was affected by re-
ligious convictions, evident from his early history paintings
to his late work *Allegory of Faith* [...]

To judge from his magnificent *Art of Painting*, it would
have included an awareness of the theoretical foundations
of pictorial representation. The number of emblematic ref-

erences in his work indicates that he felt that nature and natural forms can lead to a deeper meaning of human experience. Finally, it would appear that Vermeer had an interest in cartography, music, geography, astronomy, and optics, the study of which inevitably introduced him to Neo-platonic concepts of measure and harmony found in contemporary thought. Indeed, Vermeer's efforts to achieve these very effects through perspective, proportion, and subtle compositional adjustments indicate that such ideas underlie his depictions of reality.

Vermeer, who began as a painter of large-scale history paintings and accommodated a change of subject matter with a change of style, was unique among Dutch artists in his ability to incorporate the fundamental, moral seriousness of history painting into his representations of domestic life. His genre scenes are likewise concerned with issues fundamental to human existence. Whether conveying the timeless bond between two individuals, the bounty of God's creations, the need for moderation and restraint, the vanity of worldly possessions, the transience of life, or the lasting power of artistic creation, Vermeer's works transmit important reminders of the nature of existence and provide moral guidance for human endeavors.

Arthur K. Wheelock, Jr.
Vermeer of Delft: His Life and Artistry, in Johannes Vermeer, 1995

[Discussing *The Little Street*] For Vermeer, form clearly preceded function. He has apparently taken various details from various houses (maybe more from one than from others) and stuck them together, as if with the tie-rods and mortar that make us believe we are looking at an "actual" streetscape. The leaves of the vine that is growing up the wall of the cottage on the left, the rough bricks, the places where ridge-tiles are missing over the passage entries,

and the weathered in-need-of-attention framing of the windows are painted with such a light, almost pointillist touch that we are seduced into feeling that all this has been rendered with utter verisimilitude. The liberties he has taken include theft, or at least major borrowing, from fellow artists. The Ville, passageway, and servant-woman are more than somewhat de Hooch, while the beautifully observed children crouching on their knees are extremely similar to the children in a 1650 Houckgeest painting of the interior of the Nieuwe Kerk and William the Silent's tomb. And yet! – and yet the ultimate effect is original. The painting is an elegy for a moment which – unless Vermeer had captured it – would have slipped away for ever: the women busy with their chores, the children entranced by their game, the clouds filtering the sunlight, two doors and one window open, and air wafting through the house.

Time, halted for this instant and therefore in a sense for eternity, seems to be his essential subject. Its wear and tear is visible in the bricks and mortar, the fabric of fact that bluntly underpins our tenuous and temporary hold on existence with its many unanswerable questions, such as "What are we doing here?"

Anthony Bailey
Vermeer: A View of Delft, 2002

Locations

AUSTRIA
Vienna
Kunsthistorisches Museum
The Art of Painting, c. 1666–1667

BRITAIN
Edinburgh
National Gallery of Scotland
Christ in the House of Martha and Mary, 1655
London
Iveagh Bequest, Kenwood
The Guitar Player, c. 1672
National Gallery
A Lady Standing at the Virginals, c. 1670–1673
A Lady Sitting at the Virginals, c. 1670–1675
Windsor Castle
A Lady at the Virginals with a Gentleman (The Music Lesson), c. 1662

FRANCE
Paris
Musée du Louvre
The Astronomer, 1668
The Lacemaker, 1669–1670

GERMANY
Berlin
Gemäldegalerie
The Glass of Wine, 1659–1660
Woman with a Pearl Necklace, c. 1664
Braunschweig (Brunswick)
Herzog Anton Ulrich Museum
The Girl with Two Men, 1659–1660
Dresden
Gemäldegalerie
The Procuress, 1656
Girl Reading a Letter at an Open Window, 1657
Frankfurt
Städelsches Kunstinstitut
The Geographer, 1668–1669

IRELAND
Dublin
National Gallery of Ireland
Lady Writing a Letter with her Maid, c. 1671

THE NETHERLANDS
Amsterdam
Rijksmuseum
The Little Street, c. 1657–1658
The Milkmaid, 1658–1660
Woman in Blue Reading a Letter, c. 1663
The Love Letter, 1669–1670

The Hague
Mauritshuis
Diana and her Companions, c. 1654–1656
Girl with a Pearl Earring, c.1665
View of Delft, 1660–1661

UNITED STATES
Boston
Isabella Stewart Gardner Museum
The Concert, c. 1665–1666
New York
Frick Collection
Officer and Laughing Girl, c. 1657–1658
Girl Interrupted at her Music, c. 1660
Mistress and Maid, c. 1667
The Metropolitan Museum of Art
A Maid Asleep, c. 1656
Woman with a Lute, c. 1664
Young Woman with a Water Pitcher, 1664–1665
Head of a Young Woman, c. 1666–1667
Allegory of Faith, 1671–1674
Princeton
Barbara Piasecka Johnson Collection
St Praxedis, c. 1655
Washington
National Gallery of Art
Woman Holding a Balance, c. 1664
A Lady Writing, c. 1665
Girl with a Red Hat, c. 1665

Chronology

The following is a brief overview of the main events of the artist's life, plus the main historical and cultural events of his day (in *italics*).

c. 1591
Birth of Vermeer's father, Reynier Janszoon, son of Jan Reijerszoon, a tailor whose family had moved from Flanders to Delft in 1597.
In the Netherlands, Prince William of Orange, son of William of Orange, re-launches the anti-Spanish offensive in the Dutch Republic, aided by England and France.

1615
19 April: marriage between Reynier Janszoon, weaver, and Digna Baltens in Amsterdam.

1620
15 March: baptism of their first daughter, Geertruijt, in Delft.
The Mayflower *reaches Cape Cod.*

1622
Constantijn Huygens brings a camera obscura made by Dutch inventor Cornelis Drebbel back to the Netherlands from London.

c. 1627–1630
Reynier, known as from 1625 as "Vos," leases a tavern called *De Vligende Vos* (The Flying Fox) on Voldersgracht in Delft.
1628: Philosopher and mathematician René Descartes settles in the Dutch Republic, where he will live until 1649.

1631
13 October: Reynier Janszoon is admitted to the Guild of St Luke in Delft as a master art dealer.

Rembrandt paints The Presentation in the Temple.

1632
13 October: Johannes Vermeer, Reynier and Digna's first son, is baptized "Joannis" at the Nieuwe Kerk (New Church) in Delft.
Birth in Delft of the naturalist Anthonij van Leeuwenhoeck, who will perfect the microscope.
Rembrandt paints the Anatomy Lesson of Dr Nicolaes Tulp.
The Province of Maryland is founded by a royal charter granted by Charles I of England).
Galileo Galilei publishes his Dialogue Concerning the Two Chief World Systems.

1640
6 September: Reynier signs a statement using the name "Vermeer."
Peter Paul Rubens dies in Antwerp.

1641
23 April: Reynier buys the house with *The Mechelen* tavern attached in the market square in Delft.
Dutch surgeon Nicolaes Tulp publishes his Observationes Medicae.

1652
2 October: burial of Reynier in Delft.

1653
5 April: Johannes Vermeer officially asks for the hand of Catharina Bolnes, born in 1631, youngest daughter of Maria Thins (c. 1593–1680) and Reynier

Bolnes, separated from Maria from 1641.
Two witnesses, the painter Leonard Bramer and Captain Bartolomeo Melling, state that Maria Thins has refused to sign the consent form for the marriage, but has agreed to the publication of the banns.
20 April: marriage of Johannes Vermeer and Catharina Bolnes in Schipluy (Schipluiden), a town just to the south of Delft.
22 April: Vermeer and the painter Gerard ter Borch co-sign a document in Delft.
29 December: Vermeer is admitted to the Guild of St Luke in Delft as a master painter.
In Britain, Oliver Cromwell becomes Lord Protector of the Commonwealth.

1654
10 January: Vermeer testifies as a "master painter" in a notarial deed. His first child, Maria, is born c. 1654.
The Dutch Republic, defeated by Cromwell, is forced to accept the Navigation Act, which will adversely affect Dutch maritime trade.

1655
14 December: Vermeer and his wife Catharina act as guarantors for a loan taken out by Reynier, Jan's late father. The document is signed "Johannes Reijnijersz. Vermeer" ("Vosch" has been crossed out).
Using a telescope he has made himself, Dutch scientist Christiaan Huygens (brother of Constantijn) discovers Saturn's largest moon, Titian.

1656
24 July: Vermeer pays his membership fee as a master painter in the Guild of St Luke in Delft. *The Procuress* is signed and dated.
Death of the Dutch painter Gerrit van Horthorst.
Diego Velázquez paints Las Meninas.

1657
18 June: first will of Maria Thins drafted (she will make a further five), leaving her jewelry to Vermeer's daughter Maria, named after her, and 300 guilders to Vermeer and Catharina.
30 November: Vermeer borrows 200 guilders from Pieter Claesz. Van Ruijven, a wealthy future patron.
France and England unite against Spain.
Dutch musician Jacob van Eyck dies.

1660
27 December: burial of "a child of Johannes Vermeer [living] on Oude Langedijck" in the Oude Kerk in Delft. First evidence of Vermeer and Catharina's move to the home of Maria Thins in the Catholic district of the city.
Marriage of Louis XIV, King of France, to Maria Teresa of Austria, daughter of Philip IV of Spain.
Samuel Pepys begins his diary.

1661
10 December: Vermeer acts as guarantor for Clement van Sorgen for a loan of 78 guilders made to the latter by Philips van der Bilt, from which he

is released one month later, on 4 January 1662.

1662
Johannes Vermeer is elected Dean of the Guild of St Luke for a two-year term.

1663
11 August: French diplomat Balthasar de Monconys visits Vermeer at his studio in Delft. Vermeer's first son, Johannes, is born (or 1664).
A protectionist English maritime trade disposition sparks a second naval conflict between England and the Dutch Republic.
In America, the English wrest the colony of New Amsterdam from the Dutch and rename it New York.

1664
Johannes Vermeer is listed in a register of Delft militia.
Death of the Spanish painter Francisco Zurbarán.

1667
Vermeer is hailed as the artistic heir to Carel Fabritius in a poem by Arnold Bon published in Dirck van Bleyswijck's *Description of the Town of Delft*.
10 July: burial of one of Vermeer children (a daughter) in the Nieuwe Kerk in Delft.
War between France and Spain over Spanish-held territory in Flanders. The Dutch make short work of the English fleet on the Thames, and the second naval Anglo-Dutch war ends with the Treaty of Breda.

Death of Gabriel Metsu, painter of scenes from Dutch life.

1668
The Astronomer is signed and dated.
The Dutch Republic allies itself with England and Sweden to form the Triple Alliance to halt French expansion.

1669
14 May: visit from Peter Teding van Berckhout, an influential citizen of The Hague, to Vermeer's studio in Delft.
21 June: van Berckhout returns to Delft and pays another visit to Vermeer.
16 July: burial of one of Vermeer's children in the family tomb in the Oude Kerk in Delft.
Death of Rembrandt. Samuel Pepys ends his diary.

1670
13 February: burial of Vermeer's mother, Digna Baltens, in the Oude Kerk in Delft.
2 May: burial of Vermeer's sister, Geertruijt, in the Nieuwe Kerk. Vermeer inherits 148 guilders and *The Mechelen* family home.
18 October: Vermeer is elected for a second two-year term as Dean of the Guild of St Luke.
William of Orange assumes control of the Dutch militia.
Van Leeuwenhoeck experiments with the microscope.

1672
Vermeer rents out *The Mechelen*.
23 May: summoned to The Hague with fellow-citizen Johannes Jordaens

(1616–1680) to value a group of prestigious "Italian" art works, sold by the leading Amsterdam dealer Gerrit Uylenburgh to the Elector of Brandenburg for 30,000 guilders, which the Elector dismissed as "tat." Both painters agree with the latter.
The Netherlands invaded and brutally sacked by French troops.

1673
27 June: burial of one of Vermeer's children in the family tomb in the Oude Kerk.
21 July: Vermeer sells two bonds totaling 800 guilders, one of which, worth 500 guilders, is in the name of Magdalena Pieters, daughter of Pieter Claesz. van Ruijven, from whom Vermeer has borrowed money.
William of Orange takes Bonn and liberates Utrecht. The English blockade of the Dutch Republic ends.

1674
Death of Reynier Bolnes, Vermeer's father-in-law. Vermeer goes to Gouda on matters related to his father-in-law's will.
The Treaty of Westminster spells the end of England's war against the Dutch Republic, and the North American Dutch colonies pass into English hands instead. The Dutch Republic and Spain join forces against France.

1675
March: his mother-in-law asks Vermeer to deal with an issue related to her will.

20 July: Vermeer borrows 1,000 guilders.
16 December: "Jan Vermeer, artist living on the Langendijk," dies and is buried in the Oude Kerk. He leaves a wife and eleven children, ten of them minors.
Prussia and Holland defeat France and Sweden at Fehrbellin.
The Greenwich Observatory is built.

1676
27 January: Catharina Bolnes sells Vermeer's last two pictures to the baker, Hendrick van Buyten, to pay off a debt amounting to 617 guilders and 30 cents.
10 February: the art dealer Jan Coelenbier buys 26 paintings from Catharina for 500 guilders on behalf of Jannetje Stevens, one of Vermeer's creditors, and takes them to Haarlem.
4 February: Catharina tries to pay off a debt to her mother by giving her *The Art of Painting*.
29 February: an inventory of Vermeer's movable goods is drawn up.
24 and 30 April: Catharina appeals to the High Court of Holland and Zeeland to cancel her debt because of the hardship she has endured following the war with France and the death of her husband.
30 September: the Delft rulers appoint Anthonij van Leeuwenhoeck as trustee of Vermeer's bankrupt estate.

1677
2 and 5 February: van Leeuwenhoeck appears before the Delft magistrates to pay off Vermeer's debt to Jannetje Stevens, who returns the 26 paintings in Jan Coelenbier's possession. They decide to put Vermeer's paintings up for public auction.
12 March: Maria Thins signs a certified note to van Leeuwenhoeck, confirming that *The Art of Painting* was made over to her on 26 February 1676 by Catharina Bolnes and therefore was not to be included in the auction of Vermeer's assets.

1677
15 March: an auction of the paintings from Vermeer's estate, including *The Art of Painting*, at the Guild of St Luke in Delft.

1696
16 May: Dissius collection auctioned in Amsterdam, comprising 21 works by Vermeer.

Literature

Studies:

Philip Leslie Hale, *Jan Vermeer of Delft*, Boston 1913

P. T. A. Swillens, *Johannes Vermeer: Painter of Delft 1632–1675*, Utrecht and Brussels 1950

Lawrence Gowing, *Vermeer*, London 1952 (revised ed. 1997)

Vitale Bloch, *All the Paintings of Vermeer*, London and New York 1963 (first published as *Tutta la pittura di Vermeer di Delft*, Milan 1954)

Hans Koningsberger, *The World of Vermeer, 1632–1675*, Amsterdam 1967

Albert Blankert, John Michael Montias and Gilles Aillaud, *Vermeer*, New York 1988

John Michael Montias, *Vermeer and his Milieu: A Web of Social History*, Princeton 1989

Edward A. Snow, *A Study of Vermeer*, Berkeley 1994

Jørgen Wadum, *Vermeer Illuminated*, The Hague 1994

Martin Bailey, *Vermeer*, London 1995

Arthur K. Wheelock, *Vermeer and the Art of Painting*, New Haven and London 1995

Arthur K. Wheelock, Jr., (ed.) *Johannes Vermeer*, The Hague 1995

Daniel Arasse, *Vermeer: Faith in Painting*, Princeton 1996

Michel van Maarseveen, *Vermeer of Delft: His Life and Times*, Delft 1996

Tracy Chevalier, *Girl with a Pearl Earring*, London 1999

Erik Larsen, *Vermeer*, New York 1999

Anthony Bailey, *Vermeer: A View of Delft*, New York 2002

Philip Steadman, *Vermeer's Camera: Uncovering the Truth Behind the Masterpieces*, New York 2002

Irene Netta, *Vermeer's World: An Artist and his Town*, Munich and London 2004

Walter Liedtke, *Vermeer: The Complete Paintings*, New York 2008

Max Kozloff, *Vermeer: A Study*, Rome 2011

Website:

Jonathan Janson, *Essential Vermeer*: http://essentialvermeer.20m.com

Background:

Madlyn Millner Kahr, *Dutch Painting in the Seventeenth Century*, New York 1978

Picture Credits